D1631505

-9 AUG 2024

04459679

This is
Gaudí

LAURENCE KING

Published in 2017 by
Laurence King Publishing
361–373 City Road
London EC1V 1LR
United Kingdom
T +44 20 7841 6900
F +44 20 7841 6910
enquiries@laurenceking.com
www.laurenceking.com

A catalogue record for this book is available
from the British Library.

ISBN: 978 1 78067 908 2

Series editor: Catherine Ingram
Printed in China

This is
Gaudí

MOLLIE CLAYPOOL
Illustrations by CHRISTINA CHRISTOFOROU

LAURENCE KING PUBLISHING

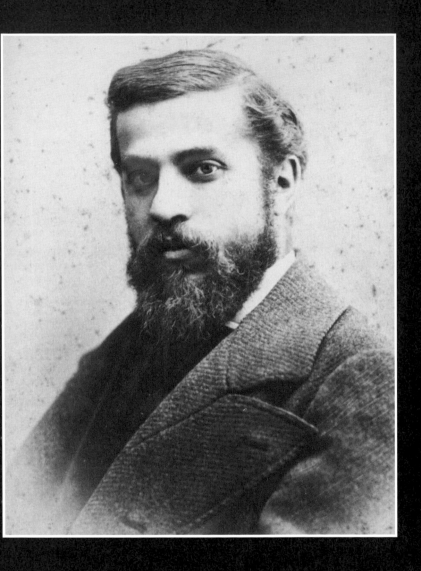

Portrait of Antoni Gaudí
Pablo Audouard Deglaire, c. 1882
Private Collection

Antoni Gaudí produced one of the strangest and most unorthodox architectural legacies to be found in the modern period. At his graduation from the University of Barcelona's School of Architecture in 1878, the director exclaimed 'Gentlemen, we are here today either in the presence of a genius or a madman!'

During his own lifetime he did become known as 'that mad, monkish architect' – and response to Gaudí's work was always drawn along the lines of love or hate. There was rarely a middle ground. The Bauhaus radical Walter Gropius considered Gaudí a technical genius, but Pablo Picasso thought him a sanctimonious reactionary.

After his death, Gaudí was classified for a time as an Iberian interpreter of Art Nouveau, but his techniques and methods for designing buildings have inspired generations of architects. More than any of his architectural contemporaries, his work continues to capture the public's imagination.

In his native Catalonia he is a great hero – a champion, promoter and saviour of the region's distinct culture. For the Catholic faithful he is 'God's architect', whose pious example has carried him along the path to sainthood.

But at his core Gaudí held a deep love of the natural world and a desire to translate its basic principles into a magnificent and humane architecture.

Coppersmith's son

Although Gaudí would spend most of his life in Barcelona, he was actually born 100 kilometres to the south, in Reus, on 25 June 1852. His father was Francesc Gaudí i Serra, a coppersmith, and his mother, Antonia Cornet i Bertran, the daughter of a coppersmith. Theirs had been an arranged marriage between two artisan families of modest but stable means.

Gaudí's birth was a hard one, and the weak newborn baby was rushed to a nearby church to be baptised in case he did not survive the first hours of life. He was named Antoni after his mother, as his elder brother had been named Francesc after his father.

The young Gaudí was plagued by illness, including lung infections and a long bout of rheumatoid arthritis. As an adult he claimed that his first memory was a discussion outside his bedroom door between his parents and the doctor about his expected early death. But the youngest and most sickly of all Francesc and Antonia's children would outlive them all. Later in life he came to see his childhood suffering and survival as indicating that he was chosen for a higher purpose.

His bouts of childhood illness would leave him bed-bound for long periods, spending weeks with only his imagination and the view he could see from his bedroom window – the dusty red soil, evergreens, hazelnut and olive trees, and vineyards of the Reus countryside. These colours and the bright blue of the nearby Mediterranean would stick with him into adulthood, often forming the palette with which he decorated his buildings.

Best friends forever

In those periods when he was not bed-bound, Gaudí was able to attend the local school. But he did not take to school life. The powers of observation that he had honed while ill seemed of little use to him there. Lessons were taught through repetition, which he hated and would later say encouraged only mimicry rather than invention.

A childhood friend recalled one teacher proclaiming, 'Birds have wings to fly' and Gaudí responding: 'The hens on our farm have great big wings and they can't fly at all. They use them to run faster.'

The friends he made at school would, like the landscape of Reus, remain with him for the rest of his life. In particular, he was befriended by Eduardo Toda and José Ribera, who were, by contrast, outstanding students. The three embarked on many projects, including the school newspaper *El Arlequín* (*The Harlequin*), composing poetry and – as boys do – roaming the countryside.

Boy's own adventures

Reus sits in the heart of the region of Catalonia, in the northeast of Spain. For much of the medieval period Catalonia was either a sovereign principality or the seat of the rulers of the kingdom of Aragon. Even following the unification of the kingdoms of Aragon and Castile and the creation of Spain at the end of the fifteenth century, Catalonia kept much of its political autonomy until the eighteenth century. But even with the loss of self government to the Spanish state, the region proudly retained its own language and distinct cultural traditions. By 1850, it was one of Spain's most prosperous and industrializing regions, and with the instability of the national government, Catalonia began to foster hopes of asserting again not only its cultural but also its political autonomy.

Reus and its environs were rich in architecture dating from prehistory through the Middle Ages. By exploring this heritage, Gaudí and his friends became Catalan patriots, passionate about its preservation and promotion.

One site that particularly attracted them was the monastery of Santa Maria de Poblet, which from the twelfth century had been one of the great centres of Cistercian monasticism in Catalonia. However, in the late 1830s it had been subjected to the Ecclesiastical Confiscations of Mendizábal. Its community was dispersed and its contents confiscated by the Spanish government, if they had not already been pillaged by the mob who had set many of the buildings on fire. By the time Gaudí and his friends discovered it in 1867, most of the remaining roofs had caved in. The three teenage boys devised a thorough and incredibly ambitious plan of restoration.

It was decided that Gaudí would be in charge of rebuilding walls to prevent any future looting, Ribera in charge of researching the history, and Toda in charge of building a library and archive of Poblet, as well as writing a monograph on the site – the *Manuscrito de Poblet*. The three envisioned the restored Poblet as the home of an idealized socialist community – a dream that stayed with Gaudí and which he would try to bring into many of his great architectural projects. Poblet provided the boys with lifelong interests and cemented their futures; they would remain committed to its restoration throughout their lives. Toda went on to be a famous archaeologist, linguist and diplomat, and was placed in charge of Poblet's actual restoration 30 years later (he would also be buried there). Ribera became a respected doctor and paediatric surgeon. And the preserver-of-walls Gaudí became an architect.

Barcelona, open city

By the autumn of 1867, both Toda and Ribera had left Reus
to pursue their education further afield. That autumn Gaudí
worked in his father's coppersmithing workshop while it was
determined what he should do. Finally, early in 1868, it was
decided that he should go to Barcelona to live with his brother
Francesc, who was there studying to become a doctor. Gaudí
would first finish his pre-university coursework before entering
the science faculty of the university; that would ultimately prove
just another stage before he applied to the newly formed School
of Architecture.

Gaudí's pre-university coursework did not over-occupy his
time, and he spent much of his first year in Barcelona wandering
its medieval neighbourhoods down by the harbour (the Ribera,
Born and Gothic quarters), absorbing the centuries of rich
architectural layering. The city opened its ancient – and, by the
late nineteenth century, rather run-down – splendours to him
like a great pop-up book. He was particularly impressed by the
church of Santa Maria del Mar. It had been built in the fourteenth
century using the funds and skills of the local inhabitants. This
symbolized for Gaudí the ideal partnership between public
architecture and the community for which it was intended.

From the outside Santa Maria del Mar is a heavy, dense mass
of stone set among the narrow streets, but inside it opens up
and has an elastic character, with grand ribbed vaults typical of
high Gothic architecture. It has a unified design that is unusual
in Gothic churches, which tend to have been built over a span
of centuries by a series of royal or ecclesiastic patrons. Santa
Maria was, by contrast, built over a mere 50 years by the
people themselves. For Gaudí it was an historical precedent
for the socialist community that he dreamed of for Poblet. And
although he couldn't know it at the time, he was looking at the

architectural template for his own Sagrada Família – contrasts of darkness and light, stone and air, compression and expansion – as well as public subscription to fund the building.

Once Gaudí moved on to the university's science faculty, his studies over the next five years focused on higher mathematics such as calculus, trigonometry and geometry, as well as mechanics and chemistry. He also had to pass exams in life drawing, French and German – all standard requirements for hopeful entrants to the soon-to-open School of Architecture, to which he was formally accepted in 1874.

He lived throughout this period with his brother, and, as was usual for students, they changed their lodgings frequently, going home to Reus during the holidays. But they always stayed in the medieval heart of Barcelona – because it was inexpensive. Like many students, neither Gaudí nor his brother were flush with funds. Their parents supported their studies, and the brothers reputedly shared clothes. Nevertheless, it was at this time that Gaudí began to gain a reputation as a dandy – getting his gloves only from such-and-such a shop, his hats only from another. It must have been an act of pure economic genius to pull the whole thing off.

And, like other young men, Gaudí seems to have been part of the city's café society. In particular he is known to have frequented the Café Pelayo on the city's famous Ramblas, at the very heart of nineteenth-century Barcelona's cultural life. There he is reputed to have associated with a group of young men known for their anticlerical sentiments – in stark contrast to the marked religiosity for which he would become noted from his thirties onwards.

Not all fun and games

The 1870s was not simply a decade of exploration and growth for the student Gaudí. Real life intruded. The early part of the decade brought the deposition of one Spanish monarch, the crowning of another, a civil war and the formation of Spain's first republic. That collapsed a year later, in 1874, and the monarchy was re-established – although this time as a constitutional one. While Barcelona escaped being a battlefield, the city was nevertheless a hotbed of contending political opinion. The Restoration ushered in a calmer period in Spanish and Catalonian politics, and also an age of prosperity. Gaudí was also finally required to fulfil the mandatory national service. From February 1875 to July 1876, he interrupted his architectural studies to serve in the infantry reserves, and even received an honour for his service.

After Gaudí returned home, looking forward to taking up his studies once more, his Barcelona roommate and only surviving brother, Francesc died suddenly at the age of 25. He was followed two months later by their mother, Antonia. Within three years his sister Rosa would also die. By the end of the decade Gaudí's family was reduced to his aged father and his sister Rosa's baby daughter, Rosa Egea i Gaudí. The student architect was left the sole potential earner for the family. As a result, Gaudí began earning a living working as a machine draughtsman for the firm Padros i Barros. And, once he joined the School of Architecture, he also started to work in the practice of one of the professors, Francisco de Paula del Villar.

Gaudí's studies were not without difficulty. As a student he was known to be temperamental, equipped with a self-confidence perhaps beyond his years of experience. He regularly butted heads with his professors, rejecting their criticism of his work. He even went so far as to request that one of his projects be re-examined for a higher mark. But on other occasions he impressed his professors with the quality and accuracy of his work. His final exam project for a new auditorium for the university is a case in point. He was accused of cheating on it because he took it home to work on. Despite all the controversy, however, the school passed him (though one professor voted against him).

At this time, Gaudí kept a journal in which he described himself as being in an 'all-enveloping depression'. He clearly used his studies and work to, as he put it, 'get out of trouble'. He worked not only for Villar, but also for other professors, including Joan Martorell, who would employ and nurture Gaudí through the first stages of his career, and remain a lifelong friend.

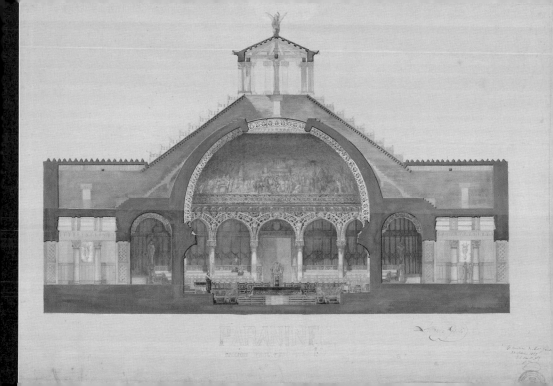

PARANINFO

Towards a Catalonian architecture

The university library and Barcelona's bookshops opened to Gaudí the whole new world of illustrated books on architecture and design that had been made possible by photography. He devoured all the contemporary books by such mid-century giants as Eugène Viollet-le-Duc, John Ruskin and William Morris (the latter two in translation, as he never learned English). He was particularly stirred by the Neo-Gothicism of Viollet-le-Duc's *Discourses on Architecture* (1858–72), as well as by photographs of classical buildings such as the Pantheon in Rome. Gaudí's interest spread to the *mudéjar* style of Moorish Spain, and in particular he was influenced by books containing Orientalist design, such as Owen Jones's *The Grammar of Ornament* (1856). The motifs and decorative designs of medieval Spain, and particularly Catalonia, would find a home in Gaudí's work, especially in the first two decades of his career.

Gaudí's student and early working years in Barcelona coincided with a movement known as the Renaixença (Catalan for Renaissance). The aim of the Renaixença was to revive and restore Catalan culture, heritage and language, which for many centuries had been suppressed in favour of a broader Spanish (or Castilian) tradition. The Renaixença was driven by poets, playwrights, novelists, linguists and philosophers, as well as architects and artists. But it was not purely a cultural phenomenon; it was also highly political, and proved a profound influence on the young Gaudí.

Lluís Domènech i Montaner, a young professor at the School of Architecture (only two years older than Gaudí), was a leading figure of the Renaixença, and Gaudí and many of his fellow students were also swept up into it. For Gaudí, the movement's interest in Catalonia's medieval heritage chimed naturally with his own passions. In 1878 Domènech wrote a seminal article, 'In Search of a National Architecture', which argued for an eclecticism (i.e. the adoption of aspects of earlier architectural styles) that would provide a connection between the Catalan architecture of the past and that of the present. He also called for architectural ornamentation that would reflect the Catalan character, and championed structure as the heart of the 'first principles' of architecture. The article became the bible of Catalan modernism.

Gaudí always stated that he was a doer, not a writer, and there are very few texts by him to shed light on the thinking behind his work. However, one surviving manuscript entitled 'Ornamentation' from 1878 shows the 25-year-old Gaudí reacting to Domènech's article. In it he agrees that nationality

Pages from Owen Jones's *The Grammar of Ornament* (1856) featuring medieval and *mudéjar* ornament and design.

and its customs determine 'the character of an object', and that national character should be 'the criterion for ornamentation'. But Gaudí defined ornament, and thus beauty, as pure geometry. He also believed that it should have colour: '[ornament should] be polychromatic; [since] nature does not present us with any object that is monotonously uniform'. In this way, he took a much more radical position than Domènech, maintaining that geometry and nature defined the criteria for ornament, and so defined national character.

Domènech and Gaudí never did quite see eye to eye. In fact, it was rumoured that Domènech was the professor who voted against Gaudí's qualification as an architect in March 1878.

Which style?

John Ruskin and Eugène Viollet-le-Duc were at the heart of the debates taking place about Renaissance and Gothic architecture, rekindling and romanticizing the relationship between architecture and nature. They asserted that an 'honest' architecture was one crafted from nature, and that materials would express themselves.

Venice and the Renaissance

Ruskin provided Gaudí not just with an introduction to Venice and the Renaissance, but also with the values and principles that should make up society and be reflected in its architecture.

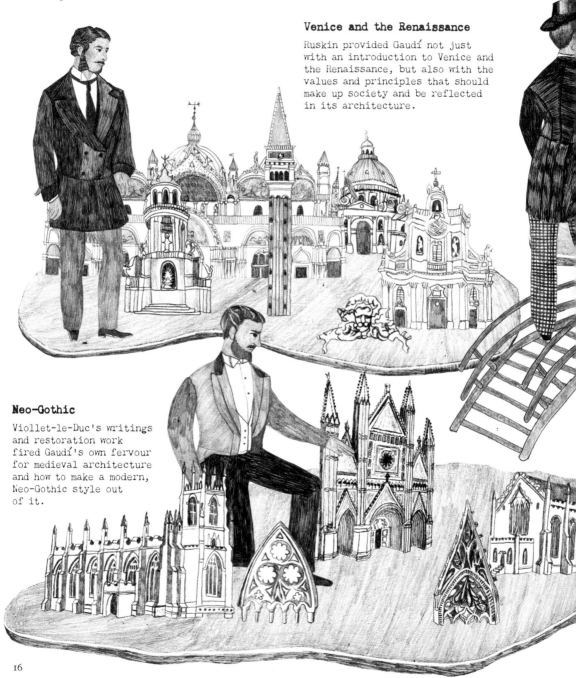

Neo-Gothic

Viollet-le-Duc's writings and restoration work fired Gaudí's own fervour for medieval architecture and how to make a modern, Neo-Gothic style out of it.

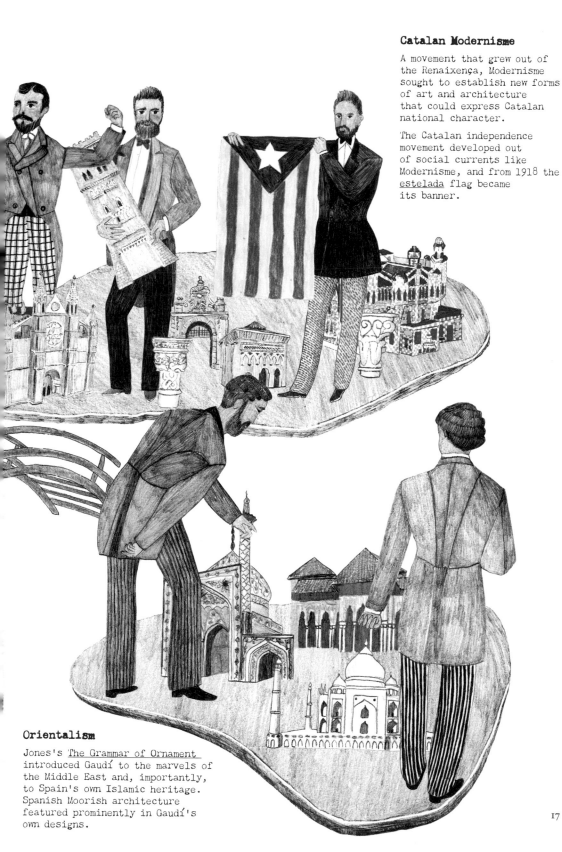

Catalan Modernisme

A movement that grew out of the Renaixença, Modernisme sought to establish new forms of art and architecture that could express Catalan national character.

The Catalan independence movement developed out of social currents like Modernisme, and from 1918 the estelada flag became its banner.

Orientalism

Jones's The Grammar of Ornament introduced Gaudí to the marvels of the Middle East and, importantly, to Spain's own Islamic heritage. Spanish Moorish architecture featured prominently in Gaudí's own designs.

17

Excursions and Departures

Part of the Renaixença movement were the Excursionista societies, whose members went on trips around Catalonia to discover and explore the region's architectural heritage. In 1879, Gaudí became a very active member of the Barcelona society, as was his old friend Eduardo Toda and several professors and students from the School of Architecture (including Domènech). In the society's visit to Poblet, Gaudí arranged for the ruins to be illuminated in order to demonstrate his vision for the abbey's restoration.

The excursions also went further afield, into France, allowing Gaudí to examine his hero Viollet-le-Duc's work at first hand with the cathedral in Toulouse and the walled city of Carcassonne. This also allowed him to form and develop his own ideas about how to restore and maintain such ancient structures. Inevitably, the young architect's own ideas began to replace those of his hero. Gaudí joked sarcastically upon seeing Viollet-le-Duc's restoration of Toulouse cathedral that the excursion could end then and there, and described his restoration of Carcassonne as 'too scenographic'. Viollet-le-Duc had gone too far, sacrificing the simple integrity of the medieval forms to theatrical effect.

But while Viollet-le-Duc transgressed in practice, Gaudí believed absolutely in Viollet-le-Duc's theory that

> when you discover the secrets lying behind the finest works in the bosom of the highest and most beautiful civilizations, you quickly recognize that all these secrets can be reduced to just a few principles, and that, as a result of the sort of fermentation initiated when they are combined, the 'new' can and must appear unceasingly.

For Gaudí this reduction and recombination would be the animus behind all his work. His first project upon leaving the School of Architecture was a desk for himself. He used Viollet-le-Duc's principles, but reorganized them. Constructed of wood and applied wrought-iron decoration, the desk was simple in idea: structure and ornament must be synthesized and connected to the earth. The horizontal lines symbolized water, with the large, round writing top designed as a floating leaf. The decoration in iron represented all the animals that live on or around water: dragonflies, butterflies, bees, insects, lizards and snakes. The legs of the desk tapered trimly to the ground. The desk from a distance took on a boat-shaped form, floating in Gaudí's metaphorical water, almost defying gravity and the laws of physics. The desk would travel with Gaudí wherever his office moved – ultimately all the way to the workshops of the Sagrada Família. There it was lost forever in the fires of the Civil War in 1936, returning to the earth in the form of ash.

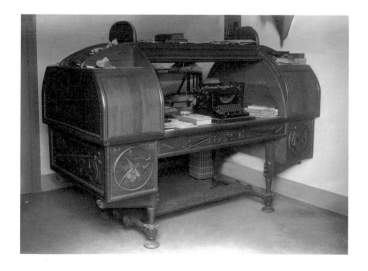

Work desk

Antoni Gaudí, 1878
(Destroyed 1936)

The ideal home

During the three years following his qualification, the new architect began being given projects that could have proven him either the 'genius' or the 'madman' – depending on whom one talked to.

One of his very first commissions came from the city of Barcelona in 1878, for street lamp posts. The project had a tiny budget, but Gaudí designed two prototypes made of stone and wrought iron, with glass detailing. One version had just three lamps, while the other had six at varying heights. Both prototypes sported the city's colours of red, gold and blue against black. They were designed and made in collaboration with the carpenter Eudald Puntí, who had a large and successful workshop on Carrer Cendra in Barcelona that also worked in stone and metal. The lamp posts were actually made and assembled there. Puntí's workshop was where Gaudí had made his desk, and it would provide him through most of his career with a fund of metal- and stone-workers, foundry men, glaziers, painters and tinsmiths. There, he made most of the furniture that he designed, even after Puntí's death in 1889. Among the artisans working at Puntí's workshop was a young sculptor by the name of Llorenç Matamala i Piñol, who made the prototypes for the lamp posts. It was the beginning of a working relationship and friendship that would last the rest of their lives.

Other commissions followed that year. The first was a display vitrine for the Comella glove company's stand at the 1878 Paris Exposition; it won the Exposition's silver medal for a display case. Another came through Gaudí's old professor and employer Joan Martorell, and was for some more furniture: a bench and prayer stool for the private chapel of the Marquis of Comillas. The convent where his young niece Rosa was at boarding school even commissioned him to design the frames for a pair of altarpieces.

Gaudí also set down on paper his ideas about what made the ideal home. Unsurprisingly for a committed Catalan modernist, he made an analogy between the nation and the family home, which he refers to as the *casa pairal* (manor), stressing that the house should 'exert a moral influence on the inhabitants'. Of course, the architectural model for this moral instruction was God's own creation, nature itself.

Workers' rights

Around 1878 Gaudí also became involved with his first model community. The Sociedad Cooperativa La Obrera Mataronense had been founded in 1864 as a socialist cooperative to protect workers' rights. The cooperative, which wanted to build an entire compound for its facilities in Mataró, approached Gaudí because he shared its passion for an egalitarian society. Gaudí took on the design of everything, from the stationery to the company banners to the buildings. The compound was to include workers' housing, a machine shop and a clubhouse in a symmetrical plan. However, only two workers' houses, a bathroom and the machine shop were constructed, and today only the machine shop still stands. It was Gaudí's first attempt at using a parabolic arch – albeit not a true one, since it did not extend all the way to the ground. He devised slogans such as 'Comrade, be sound, practise kindness!', 'Do you wish to be an intelligent man? Be kind', 'Too much courtesy is proof of a false education' and 'Nothing is greater than fraternity' to be hung on banners from the arches over the workers below. Gaudí worked with the cooperative for the next five years, and their vision of a workers' society would further evolve his approach to architecture and architectural practice.

Banner for the Cooperativa La Obrera Mataronense designed by Gaudí and embroidered by Pepeta Moreu.

An affair of the heart

Although Gaudí never married, and – owing to his deep Catholic faith – is often remembered as celibate, he did as a young man fall in love. Josefa 'Pepeta' Moreu and her sister were teachers at the cooperative's school and were also in charge of embroidering the banners that Gaudí had designed. However, he had made the designs so intricate that the sisters asked him to simplify them. Pepeta was a republican, highly educated, a swimmer (unusual for a woman at the time) and very beautiful. The young architect's admiration quickly blossomed.

Gaudí became a regular guest at the Sunday meetings and dinners of the Moreu family, conversing with Pepeta regularly, but never declaring his feelings. Those close to him disagreed about why, and how, his involvement with the Moreu dinners ended. Some said that he did ask her to marry him, only for her to reveal her engagement to a wealthy businessman. Others said she pre-empted the declaration by appearing at dinner wearing an engagement ring. Gaudí himself later claimed that he had stopped seeing her of his own accord. Once he became architect of the Sagrada Família, he did not visit Mataró again.

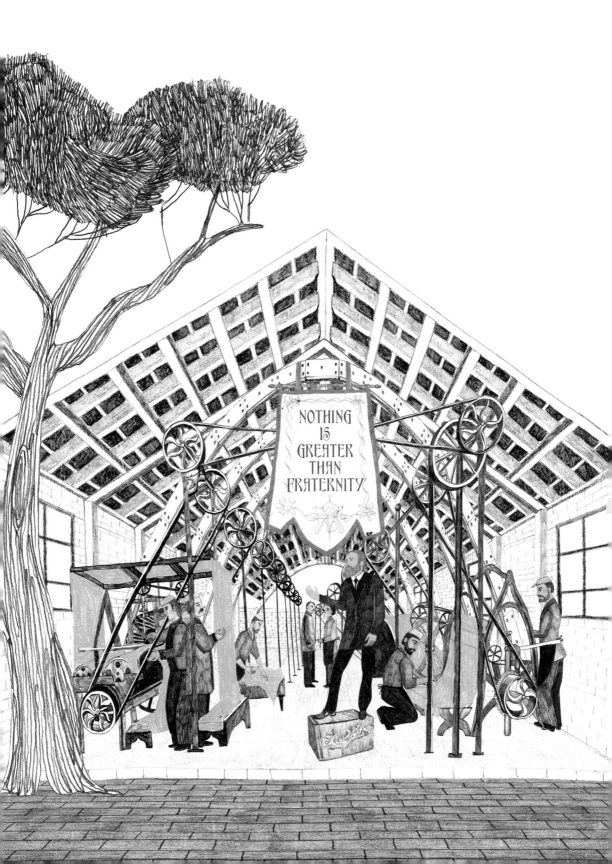

Manifest destiny

The young architect soon became caught up with another ideal society, this time one with a Christian spiritual base. In the early 1860s the book dealer Josep Maria Bocabella Verdaguer founded the spiritual association of St Joseph. A wealthy and devoutly religious man, Bocabella bought a plot of land on what was then the outskirts of Barcelona in 1881, only a few years after he had begun a public subscription for the purpose of building a major new church – to be known as the Basílica i Temple Expiatori de la Sagrada Família (Basilica and Expiatory Temple of the Holy Family). Built, like Santa Maria del Mar before it, by the local community and dedicated to Barcelona's patron saint, St Joseph, the church was meant as a protest both against industrialization and the sidelining of Catalan culture. It was to be not only a church, but also a community – one bound together tightly by a commitment to the Catholic faith.

Francisco de Paula del Villar, the first of Gaudí's old professors for whom he had worked while still a student, was initially appointed as the church architect. But as soon as the first cornerstone was laid, in 1882, Villar's relationship with the Sagrada Família association disintegrated over the choice of material for the crypt columns (the very first part of the church to be built). Villar resigned and another of Gaudí's old professors, and his friend and employer, Joan Martorell, was then considered. But he was ultimately set aside because he was already the association's assessor of the church's plans – and becoming its architect would constitute a conflict of interest.

Bocabella's deep faith led him to the solution. In a dream, he saw a young architect with piercing blue eyes. A short time later, he met Gaudí in none other than Martorell's office, where he was working as an assistant architect, and Bocabella knew instantly that he had found the next architect of the Sagrada Família. When Gaudí became the official architect in November 1883, he had built only the machine shop of the Obrera Mataronense. He was known among those who employed him, such as Martorell, as a skilled and talented young architect, but he was virtually unknown to the rest of Barcelona and Catalonia. His appointment quickly catapulted him to a level of fame and respect reserved only for the uppermost echelons of Barcelona's architecture elite.

The quick increase in Gaudí's level of responsibility (and, ultimately, liability) would be stabilized by his own deepening faith, his growing relationship with Bocabella and his trust in the older man's vision for the Sagrada Família. He began to show the strength of his architectural convictions, particularly when he requested complete freedom to revise the designs for the church, ridding himself of any ties to those made by Villar. His request was granted.

Gaudí later came to believe that his selection as architect of the Sagrada Família was due to God's intervention. For him the central mission of the project was engraved on that cornerstone of 1882: that the temple would be built 'to the greater honour and glory of the Holy Family, so that all sleeping hearts may be awakened from their indifference, that faith may be exalted and warmth instilled in charity…'

Increasingly from this point, Gaudí became the religiously passionate and celibate figure of popular imagination. However, in 1884 he was rumoured to have become romantically involved twice more. Both times the love was tragically unrequited. The first instance is known only through a much later story written by a friend, the poet Joan Maragall, in 1912 about a 'hermit' architect with 'eyes of violet on a palely coloured face' (that is, Gaudí), who fell in love with a foreign girl (later claimed by another associate to be French). But she was already engaged to another, and moved to America to be with him. Gaudí subsequently fell in love with an extremely devout woman, although it is not known whether she loved him in return. When she became a nun, Gaudí's own religious practice deepened exponentially. Later in his life, he was adamant that marriage had never been for him, and that he had never felt any propensity towards it.

Casa Vicens

Even with the lift in Gaudí's reputation received from being appointed official architect to the Sagrada Família, the madman/genius prophecy of his school days was still ringing in his ears. He decided he needed to add to his portfolio more building projects that were, in his words, certain, and not just the experimental grand schemes, no matter how much fame and prestige those might bring.

In 1883 Gaudí broke ground on what would become the first of these 'certain' projects, the Casa Vicens. His client was the tile and brick manufacturer Manuel Vicens i Montaner, who wanted a villa in Gracia – then a town on the outskirts of Barcelona. The structure of Casa Vicens is extremely rational. Gaudí used the standard 15 x 15 cm tile (made by his client) as a module for measuring out the entire building. Perhaps the tile also inspired Gaudí to look to Moorish architecture, in which tiles play a great role. Building on the basic tile unit, Gaudí was able to be much more free with the organization of the house, achieving an asymmetrical plan that has multiple scales at play, with turrets, buttresses, terraces and gables protruding from its tiled exterior. The clear references to Moorish architecture on the outside are even more explicit in the highly decorative and ornate interior.

Gaudí's total design, from structure to furnishings, meant that he was not an architect who worked in isolation. Puntí's workshop made the furnishings and Matamala designed palmetto-patterned wrought-iron fencing, gates and window grates, which were made by the blacksmith Joan Onos, who would become another long-standing collaborator. Joining the group was an assistant architect, Francesc Berenguer i Mestres, who helped with the overall design for the house. He would work with Gaudí for his entire career.

Gaudí's working habits first came under proper scrutiny during this project – and myths about them (often true!) would follow him for the rest of his life. At Casa Vicens he would tear down walls and build them elsewhere in a single day, completely contradictory to the normal practice of constructing according to carefully drawn-up plans. Casa Vicens was much more of an organic process. It was rumoured that this approach almost bankrupted his client, but the men remained close friends.

Exterior, Casa Vicens
Antoni Gaudi, 1883–88
Barcelona

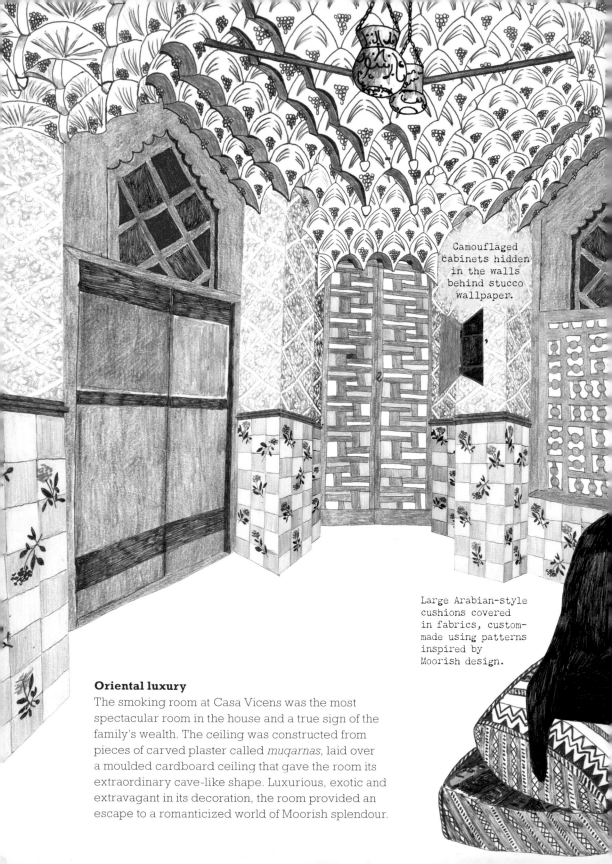

Camouflaged cabinets hidden in the walls behind stucco wallpaper.

Large Arabian-style cushions covered in fabrics, custom-made using patterns inspired by Moorish design.

Oriental luxury

The smoking room at Casa Vicens was the most spectacular room in the house and a true sign of the family's wealth. The ceiling was constructed from pieces of carved plaster called *muqarnas*, laid over a moulded cardboard ceiling that gave the room its extraordinary cave-like shape. Luxurious, exotic and extravagant in its decoration, the room provided an escape to a romanticized world of Moorish splendour.

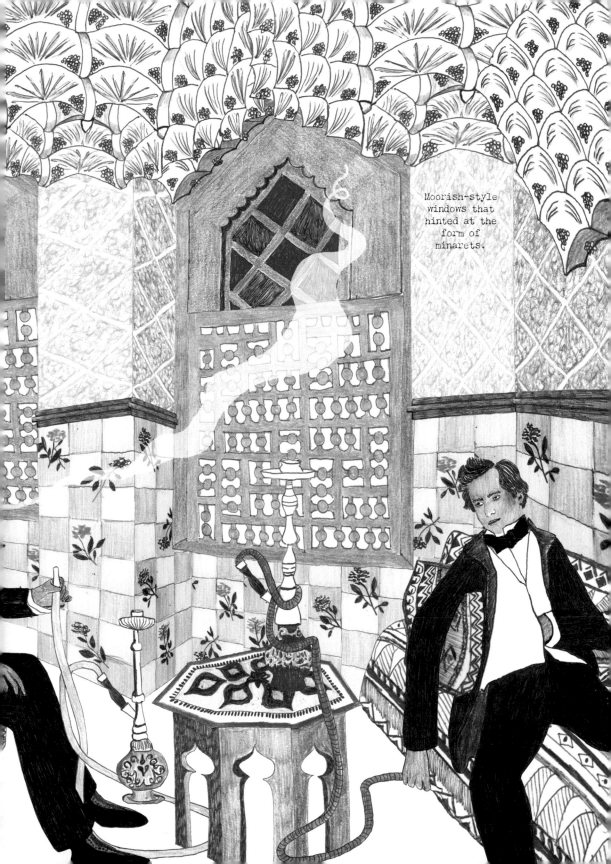

Moorish-style windows that hinted at the form of minarets.

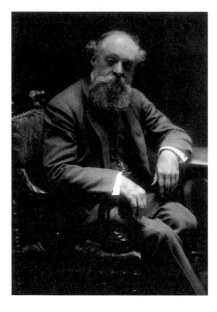

Eusebi Güell i Bacigalupi,
Comte de Güell, c. 1900.

A fine bromance

While working on Casa Vicens, Gaudí took on a commission
for a summer villa in the seaside town of Comillas, for the
influential and wealthy Máximo Díaz de Quijano. Again
organized on the basic principle of the tile unit, the resulting
house lived up to its name of El Capricho (The Whim) as a
playful Moorish/medieval fantasy. Gaudí himself only drew up
the plans for the house, and subcontracted the actual building
of it to his associate Cristobal Cascante Colom. Díaz never
lived to see the completed house (he died in 1885), but it
ultimately came into the possession of the son of one of
Gaudí's greatest patrons and friends.

The wealthy entrepreneur, industrialist and politician Eusebi
Güell i Bacigalupi had first encountered and become interested
in Gaudí's work at the Paris Exposition in 1878 (the display case
for gloves), but it was not until 1883 that he actually met Gaudí in
Eudald Puntí's workshop. It was bromance at first sight and Güell
almost immediately took on the role of patron, hiring Gaudí to
design some of the furniture for a chapel owned by his family.
Gaudí would be the Güell family architect for the next 35 years.

For Gaudí, his friendship with Güell was to be the most
important of his life, and it would also be critical in the
transformation of the architectural scene of Barcelona and
Catalonia. The Güells were the modern Catalan equivalent of
the Medicis of fifteenth-century Florence.

Güell's commissions moved quickly from furniture design to architecture. There was a hunting lodge that never got built, and which was instead replaced by two pavilions to flank the entrance of the Güell country house (or *finca* – ranch) to the southwest of Barcelona. The pavilions – a gatekeeper's lodge and a stable – continue Gaudí's Orientalist style of building on a basic unit and including large lanterns resembling minarets. The interiors feature parabolic vaults (this time true ones) to create pristine white, arching spaces. The parabolic arch became a signature of Gaudí design.

The most beautiful and culturally interesting component of this commission is the Dragon Gate (Drac de Pedrables), designed in collaboration with Matamala. Like the palmetto ironwork of Casa Vicens, it is an incredibly detailed achievement in wrought iron, featuring the dragon Ladon – the guardian of the Garden of Hesperides in Greek mythology, who was conquered by Hercules (the founder of Barcelona in Catalan tradition). This myth featured in the epic poem *L'Atlàntida* by the most important contemporary Catalan poet, Jacint Verdaguer (a close friend of Güell's and also a member of Gaudí's Excursions club). In a perfect example of Gaudí's use of symbolism, behind the gate lay the house of the man who would be influential in the revival of Catalonia.

Dragon Gate, Finca Güell
Antoni Gaudí, 1884–87
Barcelona

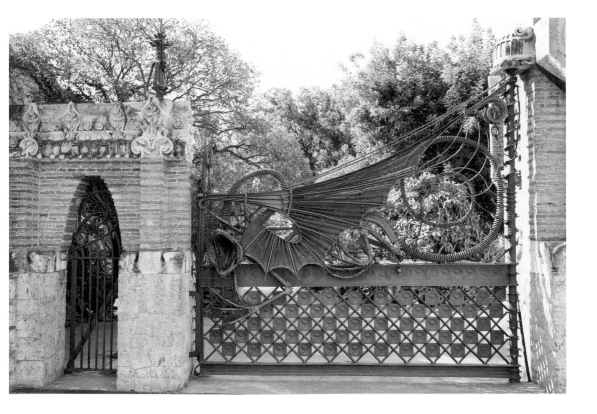

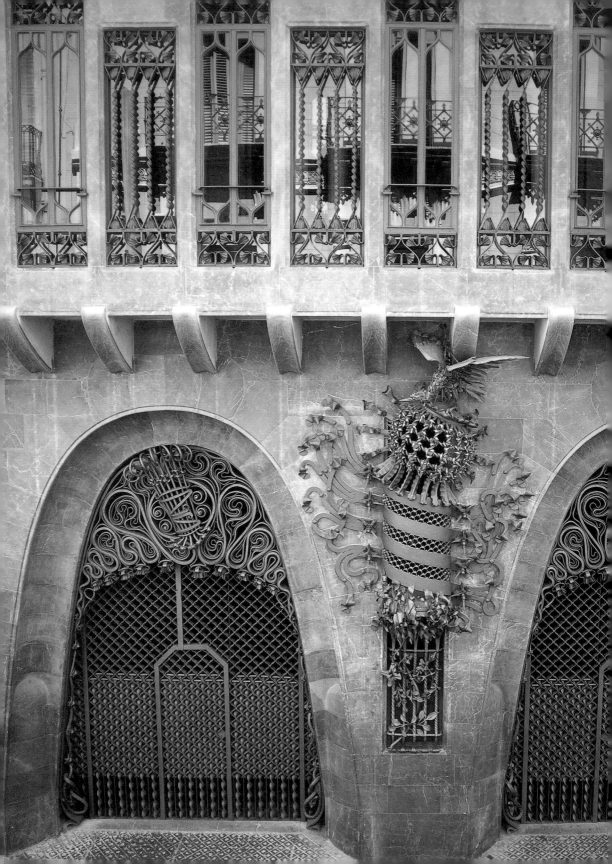

Palau Güell

The first really big Güell commission, however, was for a large town house for Eusebi in the heart of Barcelona's medieval neighbourhoods, on the Calle Conde del Asalto. In the autumn of 1885, Gaudí began work on Palau Güell – meant not just to be a family home, but also to position the Güell name as being synonymous with modern Catalonia. The finished house was described in a local paper as '[battling] against routine and fashion'. Whether or not it effectively saw off Güell's business and political rivals, it firmly established Gaudí as an architect who was very much of the past, present and future of Barcelona.

Palau Güell went through an intensive design process during which at least 22 versions of the façade were drawn up by Gaudí and Berenguer. The urban nature of the site, hemmed in by buildings and narrow streets, required very careful planning. For inspiration, Gaudí drew on some of his favourite references. The house is supported by a 'grove' in the cellar of 127 limestone columns, reminiscent of the mosque at Cordoba. This enabled Gaudí to maintain an open plan on the floors above, arranging the living spaces freely. The house almost grows out of the ground from the columns, which are joined up by his signature parabolic arch. The four floors above rise vertically with a masterful interplay of vaults, screens, windows and juxtaposed volumes, creating dichotomies of light/dark, vertical/horizontal, compressed/expanded.

Money was no object in the building's construction and design, and the detail and intricacy demonstrate as much. The ground floor featured an impressive set of wrought-iron gates, and Güell even ordered a saw from abroad that Gaudí needed in order to cut marble a particular way. Rumour has it that Güell, handed an accumulation of bills for the project, simply said: 'Is that all Gaudí has spent?!'

Façade, Palau Güell
Antoni Gaudí, 1885–90
Barcelona

His complete vision

The main street entrance of Palau Güell led through Matamala's extraordinary wrought-iron gates and heraldic sculpture up a grand flight of stairs to a magnificent central hall that rose the height of the building's three residential floors to the dome of its great central turret. Intricately designed wooden screens looked down from the upper floors on to the floor of the hall below. Along the gallery running the width of the first floor was the principal drawing room.

Lloreç Matamala was again responsible for the house's distinctive ironwork and stone sculpture.

The grove of massive pillars in the cellar were joined up by parabolic arches to support all the floors above.

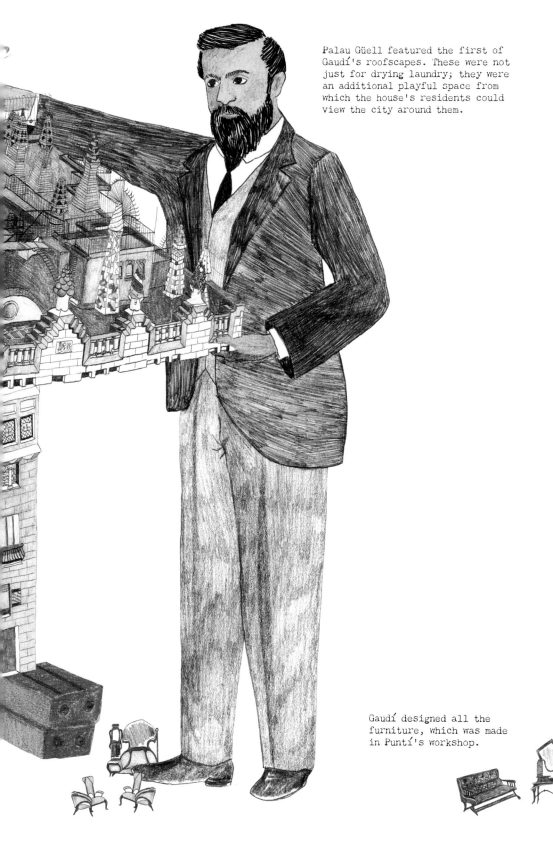

Palau Güell featured the first of Gaudí's roofscapes. These were not just for drying laundry; they were an additional playful space from which the house's residents could view the city around them.

Gaudí designed all the furniture, which was made in Puntí's workshop.

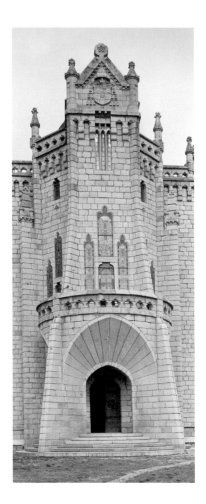

Entry porch, Episcopal Palace
Antoni Gaudí, 1883–93
Astorga

Parabolic extremes

In 1887, before Gaudí had completed Palau Güell, he received
a new commission for an episcopal palace in Astorga, in the
province of Léon. The client was the bishop of Astorga, Joan
Baptista Grau – a native of Reus and an admirer of Gaudí's work
on the Sagrada Família.

Astorga was far from Barcelona, and Gaudí, hoping to repeat the
success of El Capricho, did not at first visit the site, but simply
drew up the plans using photographs and books on the local
history that Grau sent him. He also researched the rich sixteenth-
and seventeenth-century Baroque church architecture of Léon.
When Grau received the plans, he wrote immediately to Gaudí:
'Received magnificent plans. Like very much. Congratulations.
Await letter.' Throughout the project, Grau would maintain
his enthusiasm for Gaudí's vision, even when Gaudí himself
perceived flaws in it. When Gaudí did finally visit the site, he
realized that the photographs on which he had based the design
had been misleading, and decided the best thing was simply to
redesign the entire building. What Grau clearly appreciated was
Gaudí's absolute dedication to his buildings being in harmony
with their physical environment – the palace, he said, must be a
perfect synthesis of nature, architecture and religion.

When Grau died in 1893 of a gangrenous infection, construction
was well under way, but Gaudí quit the project shortly thereafter.
Without Grau, the Astorga diocesan council had argued with
Gaudí constantly over the design. Construction halted, but
recommenced 20 years later under Ricardo García Guereta, who
changed much of Gaudí's original design. Guereta also resigned
before completing the project, and the beleaguered building
ended up serving as the local fascist headquarters during the
Spanish Civil War in the 1930s. It was not completed until the
1960s. The strongest statement of Gaudí's design is in the entry
porch, formed as it is from a parabolic arch.

Playing with pillars

Gaudí did manage to complete one building project in the province's nearby capital of Léon – although, again, in the face of local opposition. In about 1892 he was commissioned by an associate of Güell to build an imposing mansion combining residential, office and warehouse space in the centre of the city. The resulting Casa de los Botines has one of the least site-specific plans that Gaudí ever designed, perhaps because he did not really engage with the city. The locals did not really engage with him, either. Suspicious of his building techniques, they spread rumours during construction that the building was on the verge of collapse. The finished building of 1893 faced the city on each of its four sides as a turreted stone fortress. Over the doorway on the principal façade – as if making fun of the good citizens of Léon – was Matamala's sculpture of the Catalan patron saint playfully attacking a rather crocodilian dragon.

Inside, however, Gaudí opened up the structure completely. To do so, he employed a grid of cast-iron columns to support the structure, allowing the walls and rooms to be placed wherever the client desired.

The 1890s was a period of transition for Gaudí. The Casa de los Botines' restrained and tightly contained façade demonstrated his need for control, perfection and self-discipline. But the interior embodies the structural freedom that he would continue to explore using constantly evolving techniques for opening up and arranging spaces.

Making more room for God

The 'all-or-nothing' attitude of Gaudí towards his work affected all aspects of his life, and was particularly exemplified by his diet. Strictly vegetarian, he was known to subsist largely on endives and milk, occasionally fasting for part of the day. When family and friends voiced concern, he would say that he ate very little in order to leave space for the Lord.

In the early 1890s Gaudí had lost two of his closest spiritual mentors: Bocabella had died in 1892 and Grau in 1893. His spiritual practice became even more intense, and consequently his already strict diet became even more restricted. During Lent in 1894, Gaudí committed himself to a complete fast that almost resulted in his death. He became so weak that he was bedridden, and not even his father could convince him to give up the fast. Only when a friend suggested that the fast was calling attention not to a commitment to faith but to Gaudí himself (it was in all the Barcelona newspapers) did he give it up.

He did occasionally display a sense of humour about his peculiarities. Once, when his friend Cèsar Martinell (later his first biographer) dropped in on him while he was eating, Martinell offered to return later. Gaudí did not ask his friend to sit down and join him in his meal, but instead said, 'Haven't you ever seen an architect eat?'

Undulating surfaces

For four years following his near-death fast, Gaudí seemed to focus more on his spiritual life than on his building projects. However, in about 1898 he took on another Barcelona town house, Casa Calvet. Pere Calvet was a textile manufacturer and an associate of Güell.

The site for the building was extremely restricted, in the middle of a block. The interior and exterior switch positions in terms of signifying old versus new: the interior plan is very traditional, while the Baroque-inspired façade is an expressive tour de force of protruding balconies of highly detailed ironwork designed by Matamala. The balconies reputedly were inspired by Calvet's love of mushrooms.

The façade gives the impression of an undulating surface like a rippling wave, something that Gaudí would explore repeatedly in later buildings. The house was even named best building of the year in 1900 by the city council. Gaudí's public image was at its height.

Façade, Casa Calvet
Antoni Gaudí, 1898–1900
Barcelona

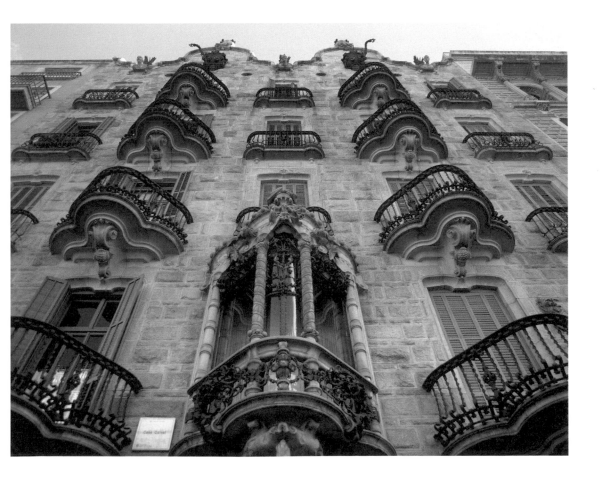

Disciplines and detractors

But Gaudí's striving for professional and spiritual perfection was by this point splitting public opinion. While his devoted friends, patrons and followers saw him as a genius, the ultimate professional and a holy man, others saw him as simply eccentric, and a growing number of the younger generation as a pompous, sanctimonious fraud. When the Spiritual League of our Lady of Montserrat shortlisted him as one of the most pious members of the organization, Gaudí responded: 'Would you please erase my name? Don't you know the *Tu solus sanctus* that we say in mass? There is only one who is perfect, and he is not in this world.' For some, that is the response of a saint, for others that of a sanctimonious prig.

Gaudí's foremost champion was the Cercle Artistic de Sant Lluc, a group founded by associates of Gaudí to promote Catholic art. For members of the Cercle, Gaudí's dedication to his faith meant that he was in opposition to young, 'godless' artists such as Pablo Picasso, whose family had moved to Barcelona in 1895. Gaudí was known to resent Picasso and all he stood for, and Picasso felt much the same about Gaudí. At one point, Picasso, recently transplanted to Paris, wrote to a friend in Barcelona: 'If you see Opisso [a cartoonist who was friends with Gaudí] tell him to send Gaudí and the Sagrada Família to hell.' In 1902, he created a small pen drawing entitled *Hunger showing a fasting Gaudí preaching to a poor family about God and Art*.

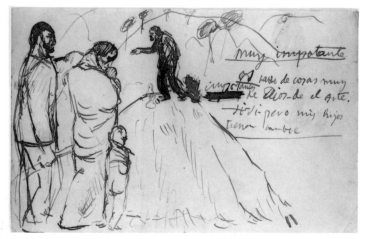

Pablo Picasso,
Hunger showing a fasting Gaudí preaching to a poor family about God and Art, 1902.

Inscribed text:

Gaudi:
'Very important.
I need to talk to you about very important matters.
About God and about Art.'

Father of family:
'Yes, yes.
But my children are hungry.'

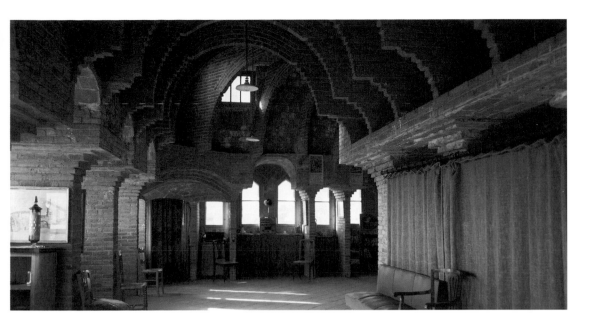

*Interior of top floor with brick
vaulting, Bellesguard villa*
Antoni Gaudí, 1900–9
Barcelona

Linking earth and sky

From 1900 the Neo-Gothic and Orientalist themes of the 1880s
and 1890s become more like elements in a visual and structural
language that is wholly and originally Gaudí's. He would bring
Catalan modernism to an almost pure abstraction. In the year
1900 itself he started several groundbreaking projects. The first
of these was the Bellesguard villa. The house was constructed
on the site of the hunting lodge of Martin I (1356–1410), the last
king of the dynasty that had ruled Barcelona since the ninth
century. Unusually, Gaudí chose to design the house completely
on his own, without any of his normal collaborators.

With Bellesguard, he began to work with three features that
play on metaphors relating to the earth and sky: the arcade of
inclined columns in the landscaped garden connecting the
building directly with the environment around it; the top-floor
use of Catalan brickwork to form a fanning system of springing
arches, exposing the materials of construction and opening
up the floor into a double-height space; and the winding and
undulating staircases that run through the building, connecting
the ground (symbolizing the earth) with the roof (sky). These
features would evolve and expand in Gaudí's later buildings in
surprising directions.

Bellesguard was finished only in 1909 – a fateful year for Gaudí
and Catalonia. But the years in between would bring the full
flowering of the architect's mature style.

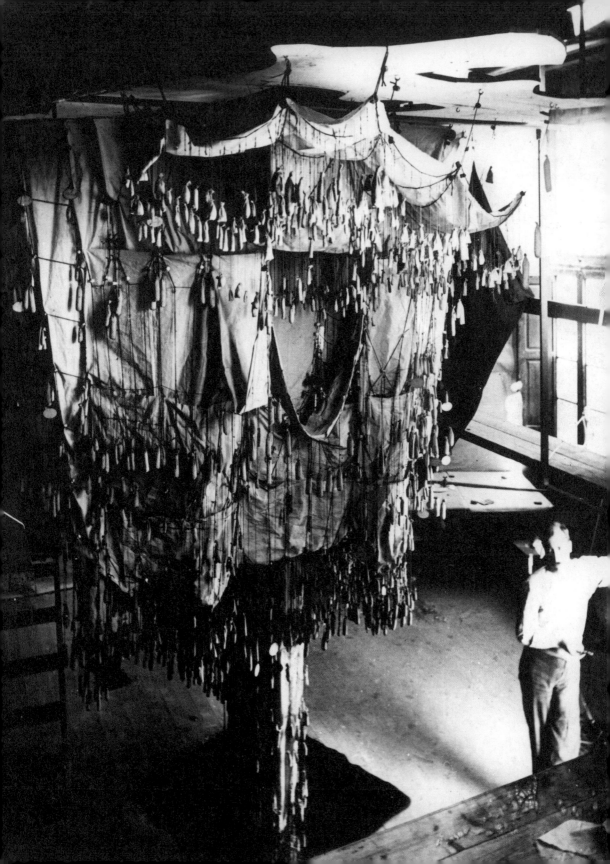

Upside-down engineering

Contrary to the criticism by Picasso and his friends of Gaudí's faith blinding him to the plight of the underprivileged, Gaudí in fact never stopped being concerned about matters of workers and social rights. In about 1900, Eusebi Güell decided to establish a workers' colony just outside Barcelona. Gaudí saw the colony as a continuation of his Poblet and Mataró projects, although this time he was primarily involved in designing the colony's church, rather than the entire campus. Gaudí instead gave Berenguer and another assistant architect, Joan Rubió i Bellver (who had joined them in the 1890s), the task of designing the workers' housing, clubhouse, school and other secular buildings using a kind of Moorish-inspired brickwork reminiscent of his earlier projects. However, with the design of the church, Gaudí broke new ground.

The parabolic arch and catenary vault from his earlier projects were here employed as the basic organizing principle for the entire building. In order to make that work, Gaudí spent ten years creating a hanging, upside-down model of the church formed by hundreds of weighted cords wrapped around and tied to one another. The idea was to allow gravity to determine, through looping, the measurements for the arcs and curves that would be needed – turned the other way up – for the church's arches and vaulting. Essentially, Gaudí was inverting the forces of compression and tension that exist in nature, and in doing so he invented a new structural theory – the very first parametric, adaptive model. Gaudí could easily adjust any point of connection in the model, and the model would adjust automatically owing to the weighting of each cord. This meant that the resulting building would be structurally in a state of complete equilibrium. This technique for form-finding has inspired generations of architects. The veneration of it could be considered almost cult-like.

The parametric model for Colonia Güell, c. 1900s.

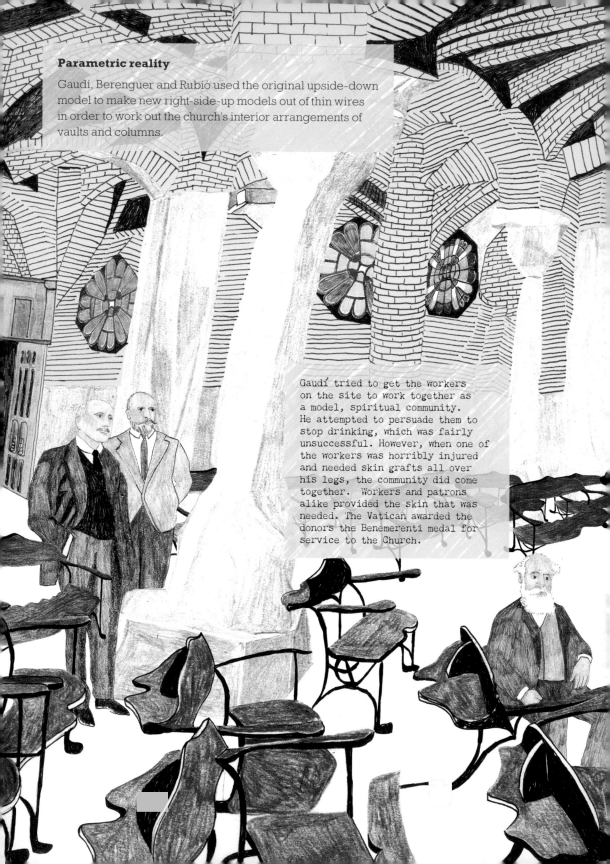

Parametric reality

Gaudí, Berenguer and Rubió used the original upside-down model to make new right-side-up models out of thin wires in order to work out the church's interior arrangements of vaults and columns.

Gaudí tried to get the workers on the site to work together as a model, spiritual community. He attempted to persuade them to stop drinking, which was fairly unsuccessful. However, when one of the workers was horribly injured and needed skin grafts all over his legs, the community did come together. Workers and patrons alike provided the skin that was needed. The Vatican awarded the donors the Benemerenti medal for service to the Church.

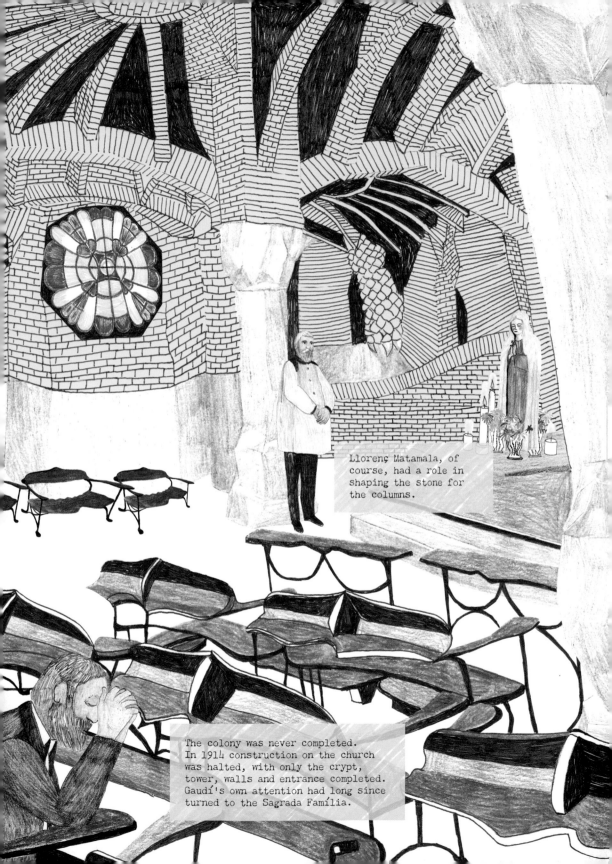

Llorenç Matamala, of course, had a role in shaping the stone for the columns.

The colony was never completed. In 1914 construction on the church was halted, with only the crypt, tower, walls and entrance completed. Gaudí's own attention had long since turned to the Sagrada Família.

Parc Güell

At the same time that Güell and Gaudí were working on Colonia Güell, they also embarked on a housing development for the city's better-heeled residents, sited in the western hills overlooking Barcelona and the Sagrada Família. Modelled on the British Garden City movement, the idea was to create a community of comfortable homes away from the smoke and noise of the city. Parc Güell was to be privately funded through its future residents buying in to the development.

The sloping terrain of the site allowed Gaudí to design a complex infrastructure of terraces, pathways and vistas to be set within lush planting. The architecture was meant to complement the natural surroundings, and Gaudí also took inspiration from the exotic and romantic 'paradises' popular in nineteenth-century garden planning.

In Parc Güell, Gaudí employed concepts and typologies from Greek classicism, but re-thought and re-imagined for modern Catalonia. Beyond the entrance pavilions, up the path and a wide staircase carving its way up the hill, was a 'Greek theatre' in the form of a covered marketplace supported by Doric-inspired columns. On the top of this marketplace was a large plaza that was both a playground for the development's children and an area in which to promenade and take in panoramic views of the city and sea. The plaza's protective balustrade was a curving and winding continuous bench.

Sixty houses to be designed by Gaudí, Berenguer and Rubió were planned for the development, but a lack of subscription meant that only a few by Berenguer and Rubió were built. One possible reason for the lack of interest was that Parc Güell was just a little too far beyond Barcelona's borders. But a more likely deterrent were the strict guidelines that Gaudí and Güell imposed on the residents. Principally, there could be no commercial activity associated with the property, perimeter walls could be no higher than 80 centimetres so as not to restrict others' views, and each house must be set at a precise placement in its given plot to allow it a view of the sea without obstructing the view of the houses behind and above it. Today such restrictions would not seem unreasonable, but in the Barcelona of 1900 they did. In 1906 Gaudí and his father and niece became three of the few people ever to live in the development. Gaudí would live in the house – designed by Berenguer – until shortly before his death 20 years later.

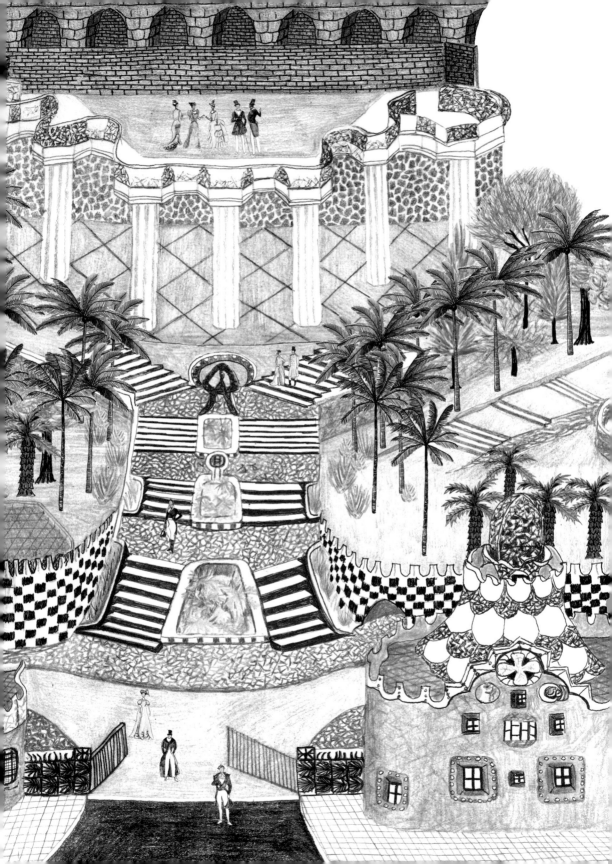

Casa Batlló

In about 1905, with Colonia and Parc Güell, Bellesguard and Sagrada Família all on the go, Gaudí took on the renovation of a town house on the Passeig de Gracia, in the middle of fashionable Barcelona. The house had been built in 1877 by one of Gaudí's former professors, Emilio Salas Cortés, with a plain, Neo-Georgian façade in five storeys with a garden at the back. Josep Batlló bought the house in about 1900 and decided that it needed modernizing – specifically Catalan modernizing. He chose Gaudí.

Next door was a project to which Gaudí felt he had to pay some homage – the Casa Amatller by his friend and fellow Catalan modernist Josep Puig. It has been asserted with some justification that on his urban projects Gaudí never took into consideration the neighbouring buildings. But he designed elements of Casa Batlló specifically so that it would harmonize with Casa Amatller. And since Amatller was shorter by a couple of floors, he even sloped Batlló's roofline so that it would meet that of Amatller's.

Here is the first time a fully mature Gaudí style emerges. Building on the unity achieved in Colonia Güell between structure and form, interior and exterior, Gaudí allowed the façade of Casa Batlló to determine where interior rooms would be. Gaudí had used the broken-tiling mosaic work called *trencadis* on several earlier projects – most notably at Parc Güell. But at Casa Batlló the *trencadis* that covers the building's exterior surfaces is of a level of refinement that is altogether new. The glistening *trencadis* mosaic that covers the undulating façade shifts from shades of green to blue to orange to purple, as if the entirety were being glimpsed beneath the rippling surface of a pool.

The sophistication and intricacy of the design do not stop there. On the first and principal floor he created a screen of windows framed with thin, bone-like columns detailed with organic, leaf-like forms. Around the existing windows further up he placed small mask-like balconies, and he crowned the building with a curved roof in scale-like tiles of vivid green, blue, pink and red. It has the shape of a dragon's back – another homage to Catalonia's patron Saint George and his dragon.

After work was finished in 1906, Casa Batlló received many nicknames. Because of the façade, both the House of Bones and the House of Yawns were favourites in the press. The Surrealist artist Salvador Dalí later said that the 'house is made from the still water of a lake ... shimmering water and water rippled by the wind.'

Façade, Casa Batlló
Antoni Gaudí, 1905–6
Barcelona

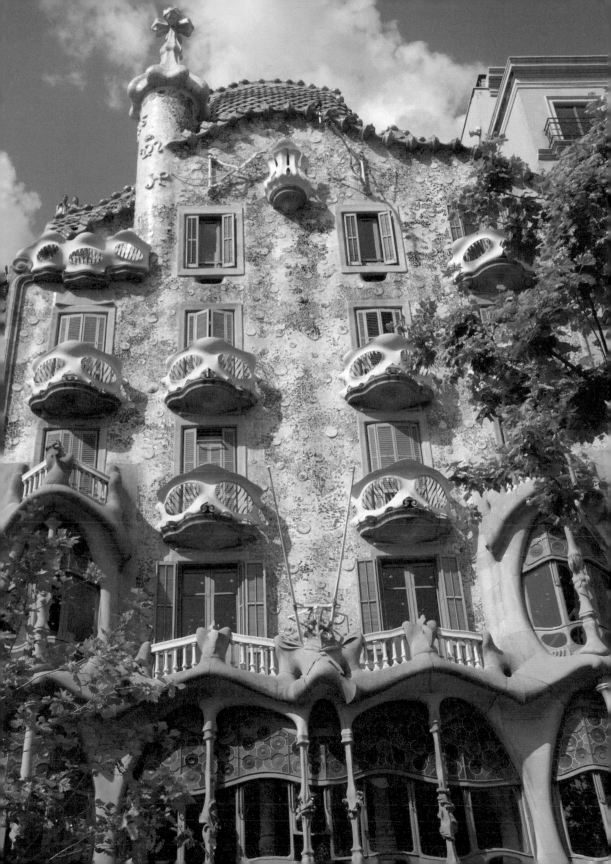

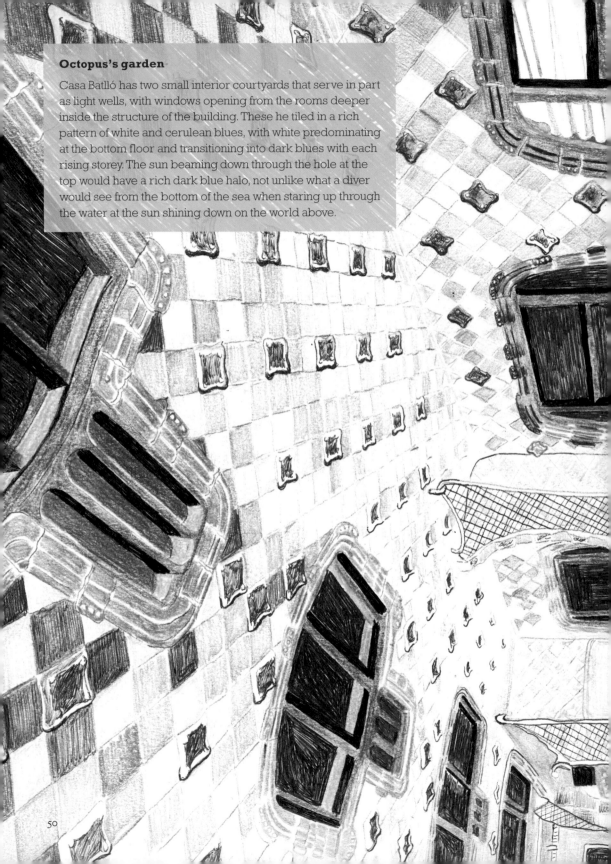

Octopus's garden

Casa Batlló has two small interior courtyards that serve in part as light wells, with windows opening from the rooms deeper inside the structure of the building. These he tiled in a rich pattern of white and cerulean blues, with white predominating at the bottom floor and transitioning into dark blues with each rising storey. The sun beaming down through the hole at the top would have a rich dark blue halo, not unlike what a diver would see from the bottom of the sea when staring up through the water at the sun shining down on the world above.

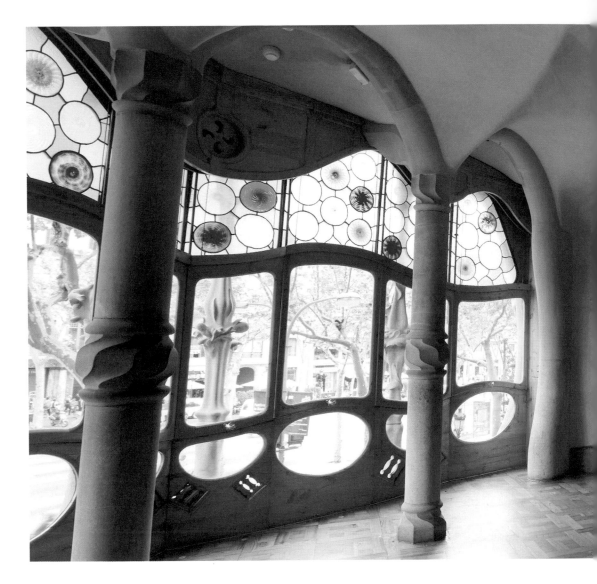

Inside the shell

Inside the house, Gaudí's focus was the remodelling of the first three floors, in which his clients, the Batlló family, would live. Again, the water themes of the exterior are echoed in both the shape and the colours of these rooms.

In the principal salon on the first floor, the façade's great undulating screen of floor-to-ceiling windows opens up the room so that it seems to float just above the street. The swirling patterns on the façade are echoed in the sculpted plaster of the ceiling – created by one of Gaudí's new collaborators, the sculptor Josep Jujol. The interior walls similarly have not

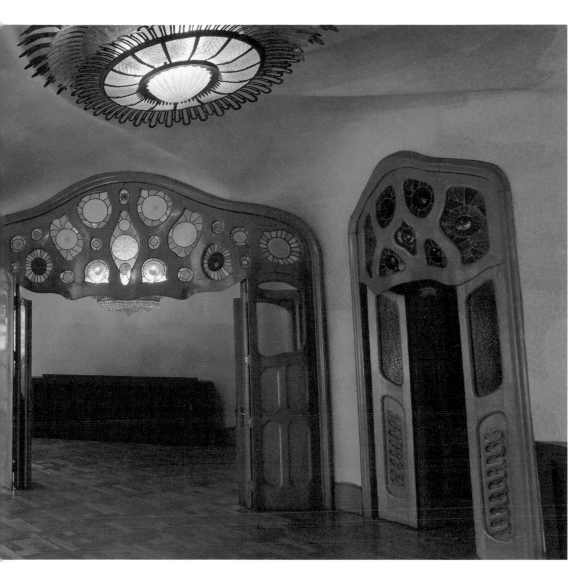

Principal salon, Casa Batlló
Antoni Gaudí, 1905–6
Barcelona

a single flat surface or straight line. But in counterpoint to the shimmering colours of the exterior *trencadis*, they were treated in warmer, neutral tones, suggestive of some submarine cavern – although an admittedly dry and comfortable one.

There is parquet flooring throughout, and – linking all the rooms on the floor, and allowing them to be opened up into an *enfilade* space – curved and carved wooden doors inset with stained glass that repeated the marine patterning of the exterior *trencadis*. The carved wood of these entryways found echoes in the furniture that Gaudí designed for the rooms.

Moulded to the body

From the moment he designed his office desk, back in 1878, Gaudí had never stopped designing furniture. For him it went hand in hand with designing the exterior and interior of a building, and he did so for most of his building projects – most notably Casa Vicens, Palau Güell, Casa Calvet and Casa Batlló. At first made in the workshop of the carpenter Eudald Puntí, Gaudí's furniture designs would later be made by a series of carvers and cabinetmakers with whom he formed working partnerships over the decades.

His first furniture following the desk – for the Marquis of Comilla's chapel – followed the standard for Neo-Gothic furniture of the time. These were very ornate, overly detailed pieces in red velvet, wood and metal. However, by the time he began work on Palau Güell, the more organically attuned Gaudí had begun to appear. The furniture for Palau Güell from the 1880s retains some of the ornateness of his earlier work, but as demonstrated by the dressing table seen opposite, the cultural references are assembled much more imaginatively, creating a dynamic and asymmetrical ensemble. The design also better expresses the qualities of the wood, displaying curving and flowing shapes that are indicative of the way Gaudí would later work stone at the Sagrada Família. In the Palau Güell furniture, applied metal ornamentation still features prominently. In the bench for Casa Calvet from the 1890s, materials other than wood have disappeared entirely from Gaudí's repertoire. The wood in this piece is carved away to form the space for the sitter's body.

The most exciting pieces of furniture Gaudí designed, however, are those he created for Casa Batlló. Here, an even purer Gaudí emerges as the pieces of furniture become more of an expression of the human body and the way it relates to the wood. Every chair he created for Casa Batlló looks as though it has been designed specifically for the comfort of the person sitting on it, without relying on traditional upholstery – the wood is carved to take the shape of the body.

In fact, these chairs look as if they could walk off on their own. A particularly surprising piece is the two-seater chair shown opposite. It has the typical qualities of later Gaudí in that it is carved out of wood, with attention paid to the sitter. Normally, a chair of this kind would be designed so that two people would be sitting together side by side. Instead, in this piece Gaudí arranges the seats of the chair so that they point out at different angles, in contrast to each other rather than in unity. Intimacy is allowed, yet isolation is constructed.

Clockwise from top left
Palau Güell dressing table
Casa Calvet bench
Casa Batlló two-seater chair
Antoni Gaudí, 1885–1906
Barcelona

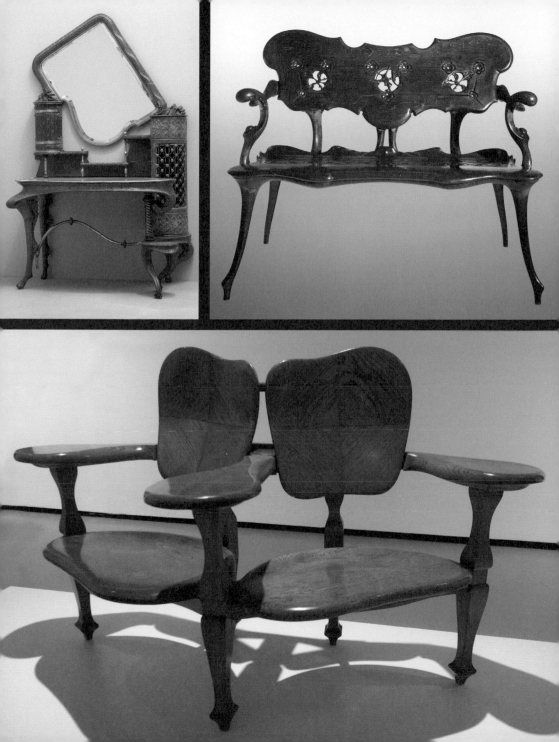

The *holocausto*

The year 1906 should have been the best of Gaudí's career. All his projects were going brilliantly and he would that year complete work on his first great mature masterpiece, Casa Batlló. But he would always qualify the year as his *holocausto* (devastation) – and the darkest time for him since the late 1870s, when his brother, mother and sister had died.

Although Gaudí was extremely successful and had powerful patrons, a devoted group of friends and followers, and a powerful faith, he was entirely undone by the death of both his father, Francesc, and his former professor and mentor, Joan Martorell. They had both supported him unhesitatingly since his student days. For family, he now had only his niece, Rosa, who seems to have grown into a depressed young woman with an alcohol problem, and was often ill. Gaudí desperately tried to get her to stop drinking, but he was no more successful with her than he was with his workers, and she would hide the bottles. Her health went into a long and steady decline before her habit finally killed her six years later.

Gaudí, in his mid-fifties, started to become 'a shadow', as his friends described it: bent over and having to use a cane to walk. But, as with his depression in the 1870s, his solution seems to have been to throw himself into his work.

Pure organic abstraction

From childhood, Gaudí had continually looked to nature both as a source of inspiration visually and as a learning tool for his designs. As his style matured this enabled him to achieve ever greater levels of abstraction. The aim was to find the essence of nature in order to discover the essence of architecture. The structure of a tree, for example, allowed Gaudí to think more organically about his approach to structure and its relationship with other parts of the buildings he was designing. The roots and trunk are the connection to the earth and ground providing the foundations and strength. Branches, leaves and the canopy create walls, envelope, roof and ornamentation.

Gaudí brought this abstraction increasingly to bear on his work at Colonia Güell, Parc Güell and the Sagrada Família. Evidence for it can also be found in the designs for other unbuilt projects of this period, such as a massive skyscraper hotel for downtown New York, or the Franciscan Mission in Tangiers. But it would be the Casa Milà project that would provide him with the greatest scope to realize his structural and design abstractions.

Elephant's foot

In the middle of his 'holocausto' year of 1906, Gaudí agreed to build an apartment building covering a vast site on the corner of the Passeig de Gràcia and the Carrer de Provença in Barcelona. As with Casa Batlló, the main floors at the bottom of the building were to be the home of the client (the Milà family), while the top floors were discreet apartments for letting.

Like Batlló, Casa Milà has an undulating façade, which, as Dalí later wrote, was drawn 'from the forms of the sea'. But the Milà façade is much more geometrically precise and less ornamental. The windows are set within the stone façade as if they are naturally formed cave openings, and the only decorative touch is the sculptor Jujol's twisting, organically shaped wrought-iron balconies, like drifts of seaweed.

Bearing in mind the partly commercial aspect of the building, Gaudí considered that in the future the apartments might need to be enlarged or reduced or otherwise have their rooms rearranged. So as he had done at Casa de los Botines, he dotted the interior with cast-iron columns to support the floors above, and allow the actual walls of the rooms to be shifted as necessary. There were those who still did not believe that such a structure would work. To demonstrate that it would, Gaudí drew floor plans with the same grid of columns in each plan, but with the walls and rooms placed differently. The next architect to devise such an open plan would be Le Corbusier in his Maison Domino of 1914/15.

Casa Milà required novel methods of construction. The self-supporting façade itself was innovative, but so was the structure for the balconies, the stairwells, ramps and chimneys. Gaudí and his contractor, Josep Bayó, even had to devise a new pulley system for lifting the huge stones of the façade into place.

However, the project was plagued with problems. Gaudí and his client fought for three years over fees, and Milà's wife despised Gaudí's designs and aesthetic from the very beginning. After her husband died, she replaced Gaudí's furniture with her own, more traditional pieces. Other complications involved the city planning department. In one such incident the city requested, at the behest of a neighbour, the removal of a column that sat too far out into the street – the 'elephant's foot'. Each time such an objection was submitted, work on the project was supposed to be suspended. But Gaudí and his team carried on regardless. Injunction after injunction over the three years of construction meant that work on Casa Milà was formally suspended more often than it was permitted to go forward.

Façade, Casa Milà
Antoni Gaudí, 1906–9
Barcelona

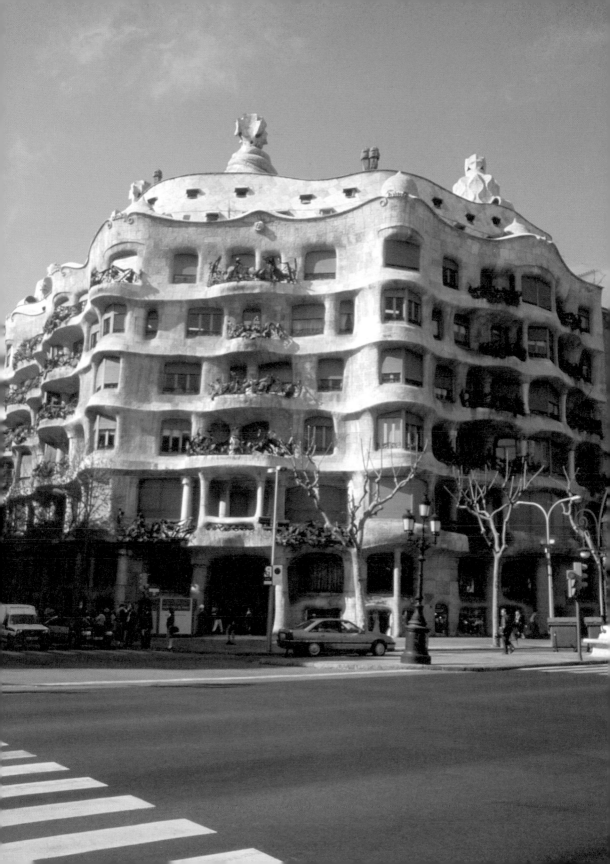

Man on the moon

Gaudí was not really having a good time, and Casa Milà was to be his last private commission. Perhaps the abstraction of the building's forms and relative lack of decorative detailing are in part a reflection of that. But if so, then even Gaudí's depression could produce work of genius.

Casa Milà's roof is arguably its crowning achievement. Formed of 247 parabolic vaults that leap out from the attic of the building to create another undulating landscape on top of the structure, it is a white moonscape of odd and even eerie sculpted chimneys and

ventilation stacks. As with many of his other buildings, the roof was meant to be used as a kind of promenade for the residents, providing spectacular 360-degree views over the city.

Long before the building was completed it was the talk not only of Barcelona, but also of the rest of Catalonia. It attracted a host of nicknames including La Pedrera ('The Quarry'), The Hornet's Nest, Zeppelin Garage and War Machine. And yet, amazingly, it was applauded by Gaudí's critics and fans alike for its breathtaking modernity.

However, the praise came too late for Gaudí. He was exhausted. In 1909, events in the city caused all work to stop on Casa Milà, and afterwards Gaudí never recommenced them. The Milà family got others to finish off what remained, and moved in in 1911, leasing out the separate apartments from 1912.

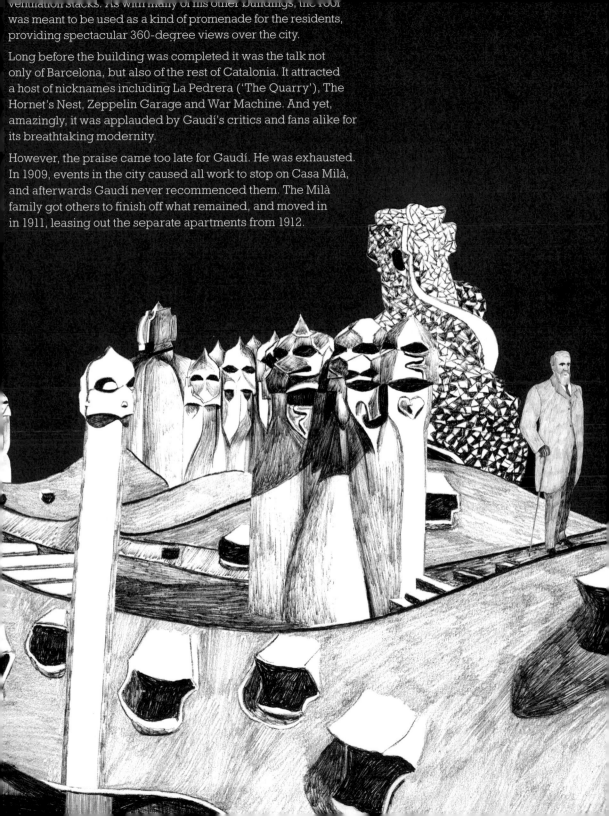

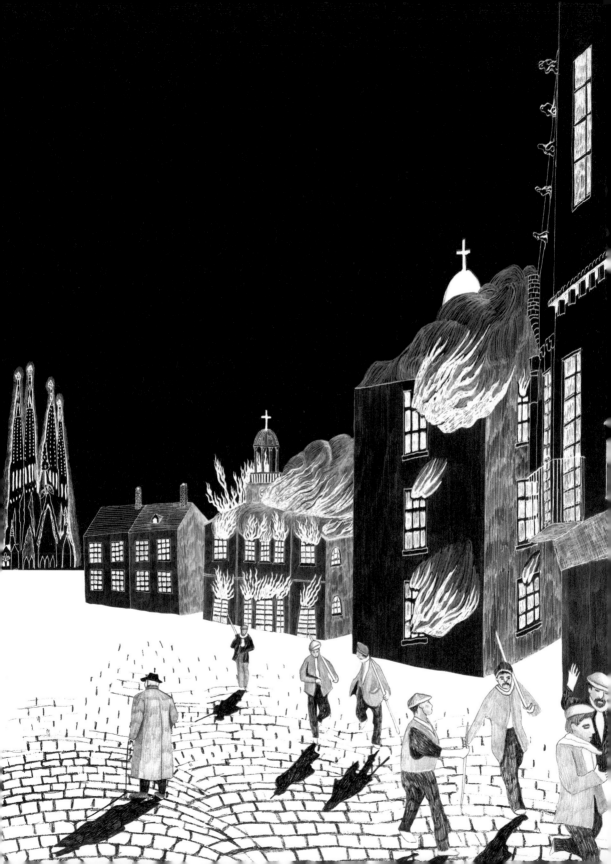

Setmana Tràgica

From 25 July to 2 August 1909, the powder keg of social unrest in Catalonia exploded in the Setmana Tràgica (Tragic Week) – a series of bloody confrontations between the working classes of Barcelona and Catalonia's other cities, and the Spanish army. Workers were angry about their low wages and terrible living conditions – and they felt exploited in equal measure by the very visibly prosperous, if Catalonian, industrial bourgeoisie, the Spanish government and the Church.

What started the riots was the sending off by ship of conscripts (recruited from Barcelona's working-class neighbourhoods) to Spain's foreign interests in Morocco. The ships belonged to the Marquis of Comillas, a noted Catholic industrialist and patriot, as well as a friend and relative of Eusebi Güell and patron of Gaudí. A crowd of onlookers began jeering and soon turned into a mob that took over the city and called a general strike. They stopped trains and overturned trams, then moved on to attacking convents and despoiling tombs and graves in the city's churches, dragging their contents out on to the streets – and, in particular, dumping them in front of the homes of Güell and the Marquis. In one night 23 religious buildings, mostly churches, were burned. The skyline of Barcelona erupted in flames and smoke. Desecration was rife.

The government ordered a crackdown, but a good portion of the city's own troops (many of whom came from the working class) refused to attack the rioters. National troops were brought in and there were pitched battles in the streets. City officials ordered all citizens to stay in their homes. Gaudí stayed in Parc Güell for much of the week, anxiously watching the city burn below, pacing back and forth on his roof. His concern was only for the Sagrada Família. Near the end of the week, when the fighting was at its fiercest, he made his way through the city to the site. Gaudí clearly believed that his sacred mission made him unassailable. Sagrada Família was, amazingly, untouched. Although it did attract a group of protesters, it was not desecrated. By the end of the week the army had put down the riots, and over 150 citizens had died in the uprising.

The repercussions of the Setmana Tràgica would be felt for many years. The national government cracked down on any manifestation of Catalan culture or nationalism, and Catalan society itself was riven between the haves and the have nots.

Back to the temple

For Gaudí, the Setmana Tràgica drew a line through all his projects, with the exception of one – the Sagrada Família. The expiatory temple on which he had been working for 26 years became his project for the people of Barcelona that would heal the divisions created by the events of summer 1909. He began at this point a daily routine that he would continue with (barring illness) for the remainder of his life. In the morning he would walk from his Parc Güell home to mass at the church of San Felipe Neri, then on to the site of the Sagrada Família, where he would work intensely, rarely stopping even to eat. In the evening, he would return to church for confession and then go home to bed.

His health, of course, suffered, and in 1910 he contracted brucellosis – a virulent bacterial infection that induces constant fever and swelling of the joints as well as violent mood swings. He suffered from it for almost a year. It was during this period that his detractors claimed he had become too arrogant and inflexible. The illness and his natural temperament meant that he would argue insatiably, and was very unlikely to back down. He attempted to cut himself off from everyone, but his closest friends and assistants refused to allow it. No matter how impossibly he behaved, they continued to care for him at the house in Parc Güell and to work by his side.

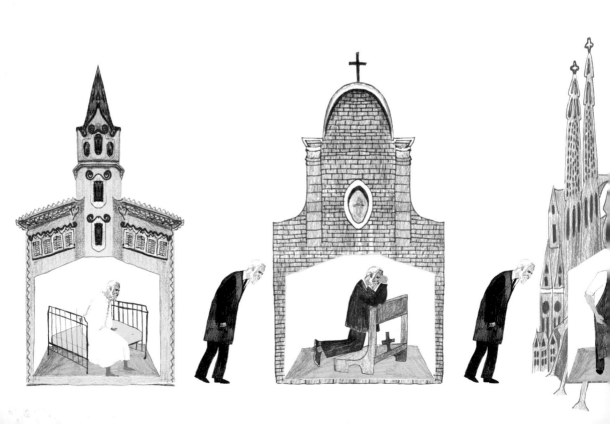

Home, however, featured Rosa continuing her alcohol-fuelled decline, and in 1912 she finally died. Gaudí took possibly his last trip out of Catalonia to visit a restoration project he had been involved with, that of the medieval cathedral in Palma de Mallorca. In 1901 the bishop of Palma had visited Gaudí in Barcelona to ask his advice on the ongoing restoration of the cathedral. Gaudí's visit was to see how, after more than a decade, his plans for a radical overhaul of the cathedral were progressing. As with Sagrada Família, they progressed very slowly, and finally in 1914 he abandoned the project entirely.

Over the next six years, while most of the rest of Europe threw itself into World War I, the Sagrada Família slowly began to rise around Gaudí. But beyond the site, time was moving on for the rest of Barcelona. The new flavour in architecture was Noucentisme, a movement that promoted an architectural aesthetic opposed to the Catalan Modernisme of Gaudí, and was explicitly against 'art for art's sake'. Instead it took its inspiration from the Vienna Secession and that movement's emphasis on order and line. In practice this meant creating highly simplified Neoclassical structures that looked forward to the Art Deco of a decade or so later. For a man uninterested in straight lines, Noucentisme was absolute anathema.

By 1918, the Nativity façade of Sagrada Família was beginning to rise, but the central nave of the church remained in the planning stage, and the Passion façade was only a drawing.

Faith in sculpture

Gaudí had been developing his vision for every aspect of Sagrada Família through models since the 1880s (in the same manner as at Colonia Güell), and work on the sculptures had occupied him and his friend and collaborator Matamala for more than thirty years. In particular, the two men focused on the Nativity façade. For the models of the figures, they used the everyday citizens of Barcelona as well as friends, live animals and skeletons (of both humans and animals). Anyone lucky enough to be selected as a model had to endure being sketched or photographed from every conceivable angle while holding the desired pose. The resulting sketches and photographs were then used to create the frameworks and plaster moulds.

From these studies, the forms for the sculptures took shape, before being translated into stone or metal by Matamala. The pair would often work on sculptures that shared an overall geometric shape, such as a cylinder, at the same time. This allowed them to test quickly whether their designs would work before permanently carving the stone or casting the metal. But it also resulted in many unsuccessful cast-offs, which littered the workshops.

Rising above the east-facing Nativity façade, Gaudí designed four towers, of which only the St Barnabas tower was completed in his lifetime. Each of the towers was meant to hold sculptures of three of Christ's twelve apostles, while the three massive portals in the Nativity façade represented the basic tenets of Christianity: faith, hope and charity. Above the central Portal of Charity was placed a depiction of the birth of Jesus, and from the tympanum of this central portal rises a single spire symbolizing the tree of life.

The style of the façade draws obvious inspiration from the medieval Gothic tradition, but the highly detailed sculpture covering the surface erodes the stiffness of Gothic imagery, asserting its own style. Each part of the sculptural programme flows smoothly into the next.

Nativity façade, Sagrada Família
Antoni Gaudí, 1883–present
Barcelona

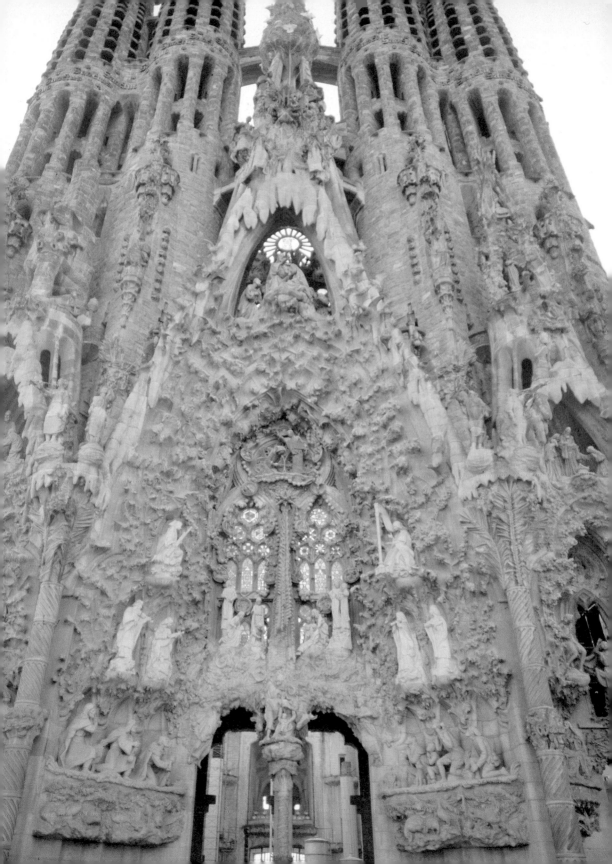

Taking a stand

By 1923, at the age of 71, Gaudí had been working on the Sagrada Família for 40 years, and had been completely absorbed in it to the exclusion of all else for a decade. The Barcelona and Catalonia of his youth were gone, swept away by the reactionary crackdown following the Setmana Tràgica. In their place were regulations from the new national government of the dictator Miguel Primo de Rivera, meant to quash Catalan identity and culture – including a law against speaking Catalan in public. All celebration of Catalan culture had also been banned, and on 11 September 1924 Gaudí was arrested while trying to enter the church of Sant Justo to attend a mass for the Catalan martyrs of 1714. Gaudí had been stopped by police at several entrances to the church and confronted them in Catalan, insisting that they had no right to deny him entry. He was arrested and abused by the police, who called him 'shameful' and told him to 'go to Hell'. There was no reason to arrest this frail, old man other than to make an example of him. Gaudí later said: 'I would have felt like a coward if I had abandoned my mother tongue in that moment of persecution.'

Those who witnessed the arrest were shocked, in particular a woman outside the police station who, upon recognizing him, broke down. Gaudí rather immodestly and melodramatically likened her to Mary Magdalene (and, thus, himself to Jesus).

Gaudí was put in a cell with two other men. He told them, 'I am a man of 72 years, and I carry no arms other than these' (holding up a crucifix and rosary beads). One of the men had been arrested for street peddling without a licence, and was unable to pay the fine required to get out of jail. Gaudí sent a note to his parish priest requesting that he pay the fine. This was done shortly after Gaudí's assistant paid the architect's own fine. Gaudí acted calmly throughout his detainment, but afterwards he said: 'Now when I think about what has happened it bothers me to think that we are going up a dead-end alley and that a radical change must definitely come.'

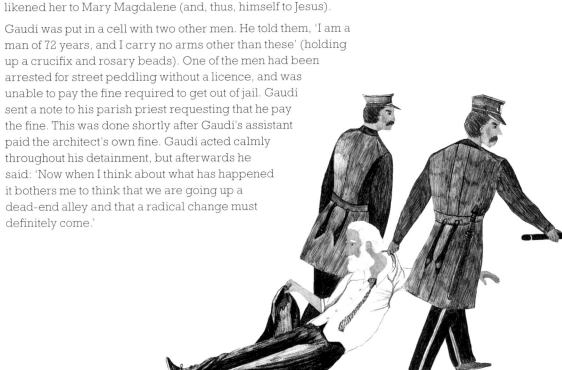

Home sweet Sagrada Família

If the government had intended to make an example of Gaudí, all it in fact did was to make him a martyr and a folk hero. Undeterred, the man himself returned to work at the Sagrada Família site. In the autumn of 1925 he decided to remove permanently from the house at Parc Güell and instead live entirely in his studio. His bed and other personal belongings were simply shoved into whatever space was available – along with all the models, drawings and unfinished bits of sculpture that littered the rooms.

Gaudí now left the site only for his daily mass and confession, and occasionally to meet an old friend. The dandy of his youth had long disappeared, to be replaced by an old, gaunt man wearing the same worn clothes day after day, and completely unconcerned with such worldly vanities. Visitors to his workshop were subjected to intense discussions revolving around the relationship between religion, nature, art and architecture. But by the mid 1920s the world had moved on, and the visitors became fewer and fewer. According to one biographer, Josep Ràfols, 'very few young architects approached him with a desire to learn from him.' But, through everything, there was always a committed group of assistants and workers on site. By this point Gaudí was receiving no salary. Each day he would attempt to solicit money from people he encountered on the street, in shops or through friends and associates, but often with little result. The lack of donations simply fuelled his own commitment to the project and to his faith. The future of the Sagrada Família, he decided, was entirely in God's hands.

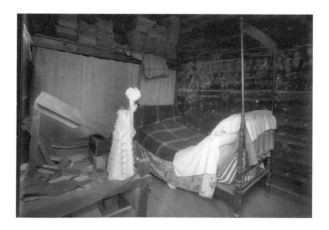

Gaudí's bed in his studio on the site of Sagrada Família, c. 1925.

An almost anonymous death

The seventh of June 1926 started out like any other day for Gaudí. After working all day on site, he started out for his evening prayer and confession at the church of San Felipe Neri in the Gothic Quarter, where he had spent his student years – half an hour's walk. According to bystanders, Gaudí was knocked off the kerb of the Carrer de les Corts Catalanes by the number 30 tram, and fell into a lamp post. The tram driver instead claimed that Gaudí had crossed the street without looking.

When Gaudí did not return to the Sagrada Família, the site's chaplain, Gil Parés, and Gaudí's assistant began to search for him along the route he would have taken, only to discover that an anonymous man who 'carried a Gospel book in his pocket and had his underwear held together with safety pins' had been taken to the Hospital de la Santa Cruz. The hospital staff insisted that they did not have the famous architect as a patient, but Parés persisted, exclaiming: 'Nevertheless, he is here and you don't realize it!' It turned out that Gaudí had been admitted as one 'Antonio Sandi'.

Gaudí remained alive for three days, in a state of semi-consciousness, described as 'serene' but in 'great pain'. He would occasionally murmur 'Jesus, Deu meu!' The corridors were lined with friends, associates, former patrons and politicians waiting to see and pay their respects to him. He finally passed away on the afternoon of 10 June. A death mask in bronze was made by his friend Llorenç Matamala's son Joan.

It was later asserted that Gaudí's personal austerity contributed to his death. His shabby appearance definitely delayed his getting to the hospital and receiving treatment: none of the bystanders who witnessed the event or who tried to help him were able to recognise him as the famous architect. A series of taxi drivers refused to take him to the hospital because they thought he was a penniless derelict. They were later fined by the mayor for their lack of generosity.

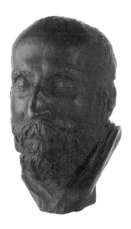

By contrast, Gaudí's funeral was 'magnificent', with thousands of mourners lining the streets from the hospital to the Sagrada Família, where he was laid to rest in the crypt. Almost every professional body, patron or associate that Gaudí had worked with sent representatives to follow the coffin. Obituaries overlooked his divisive stubbornness, focusing instead on him as a genius and a saint, whose commitment to God and deep spirituality had literally raised the Sagrada Família, which although unfinished, already dominated the Barcelona skyline.

Gaudí's death mask by Joan Matamala, 1926.

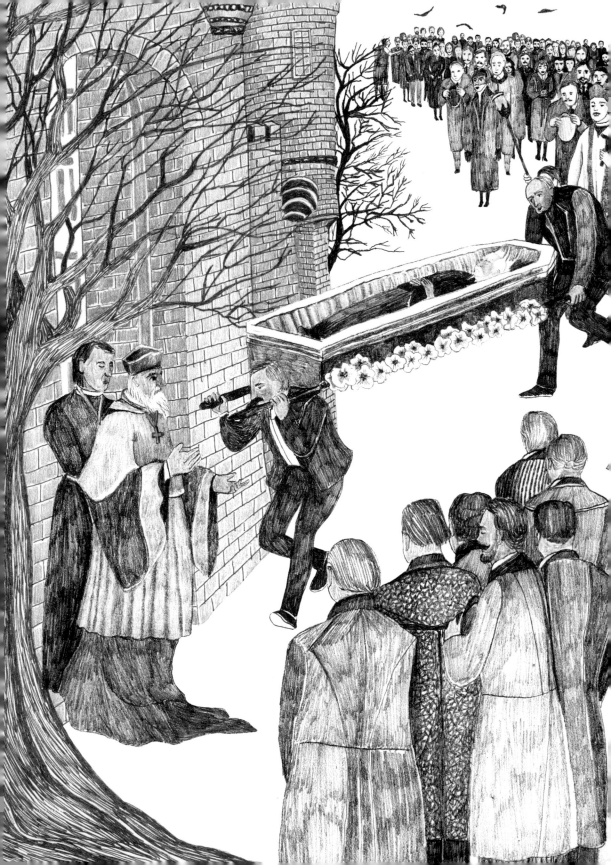

Up in smoke

By the time of Gaudí's death, the only completed part of the Sagrada Família was the Nativity façade's St Barnabas tower. After his death, work on the site slowed considerably – though it never drew completely to a halt. But without the old man at the helm to oversee all aspects of the project – from fundraising to design – much of the impetus behind the project disappeared. His studio, however, was preserved intact. Over the decades it had become not only the repository of all the work on the site, but also – with the closure of the Parc Güell house – the archive of his entire career. At the time of Gaudí's death, according to his friend César Martinell, he had designed or built over 60 projects, many in Barcelona, but also across Spain, France and even in the Americas.

And there it all remained for ten years, until Spain exploded into Civil War and no corner of the nation was left untouched. The Sagrada Família was attacked at the start of the war in 1936, the crypt broken into and Gaudí's workshop destroyed. All of his working papers, drawings and sketches were burned. The numerous and well-worked models in plaster were broken into hundreds of pieces. The successful evasion of tragedy during the Setmana Tràgica was not repeated.

The Sagrada Família and Gaudí's studio in flames, 1936.

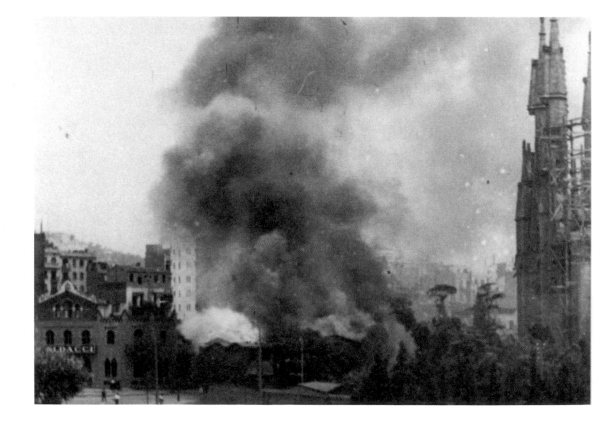

My client is not in a hurry

Even the Civil War could not put an end to Gaudí's great project, and work on Sagrada Família resumed in 1938, even before the war was over and Catalonia was officially subsumed into General Francisco Franco's repressive regime. Gaudí had recognized Sagrada Família as a labour of faith and love in the idealized vein of the construction of the great cathedrals of the Middle Ages. In testament to that, the project continued as a community effort.

One of Gaudí's close collaborators in his final years, Francesc de Paula Quintana i Vidal, took on the immediate task of repairing the damage caused during the war, particularly in the crypt. Importantly – while memory was still relatively fresh for those who had worked with Gaudí – he first focused on repairing and, in some cases, totally reconstructing the models that Gaudí had produced.

This tradition, of collaborators or close associates continuing the work of Gaudí, carried on for the next four decades, while any of them remained alive. Gaudí's vision for the Sagrada Família continued to guide progress on the building. When the memories of his collaborators could no longer provide the necessary guidance, plans were further developed using photographs of his workshop or any other documentary evidence that might give some idea of the master's plan. True to Gaudí's own spirit, when funds ran low (which they often did in the decades after the war), church organizations would lead fundraising drives. In 1961 a museum was opened in the crypt of the Passion façade (which was slowly taking shape) to bring in further revenue.

In the early 1950s the steps of the Nativity façade were finally completed, and in 1976 the massive towers of the Passion façade were finished, mirroring those on the Nativity façade on the opposite side. The sculptures for the Passion façade were completed in 1986. Progress was made slowly, but surely – and, as Gaudí had always said, 'My client is not in a hurry.'

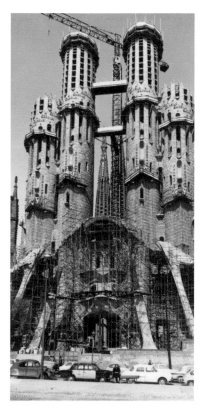

The Passion façade under construction, 1973.

Taking shape

In 1979, Mark Burry, a young New Zealand architect studying at Cambridge, 'discovered' Gaudí while researching his final year dissertation. He began at that point an almost 40-year crusade bringing awareness of Sagrada Família beyond Catalonia to the rest of the world and helping to initiate one of the most productive periods of the sanctuary's construction.

By 1990, Burry was engaged as both architect and academic consultant at the site, working alongside the Sagrada Família architects – now in their fifth generation. He began exploring the fast-developing computer technologies for architectural modeling. This development made planning and executing the designs for the remainder of the church in the 'spirit of Gaudí' a great deal easier. Using these digital tools alongside the notes and photographs left by Gaudí's earlier collaborators, they analyzed the built parts of the church. A big discovery was that Gaudí based the entire composition of the Sagrada Família on doubly-ruled surfaces. Understanding this enabled the architects to understand the geometrical decisions that Gaudí made and would have made for the rest of the structure.

By the year 2000, work had begun on the central nave and transepts and the foundations of the Glory façade. In 2010 the Sagrada Família was officially dedicated by the Pope as a place of worship. Now, more than 130 years after Gaudí began his great project, it has at last entered its final building phase. The visiting public can already appreciate the genius of how continuous structure and complex geometries translate into light, movement and purity. The expected completion date of the Sagrada Família is 2026, the centenary of Gaudí's death.

Mark Burry's computer-modelled iterations for the nave of the Sagrada Família.

Sagrada Família
Antoni Gaudí, 1883–present
Barcelona

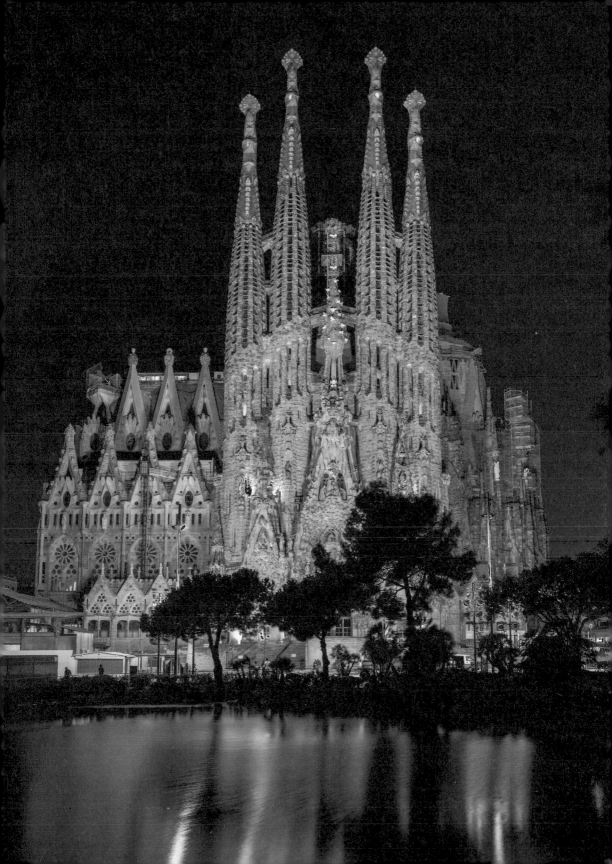

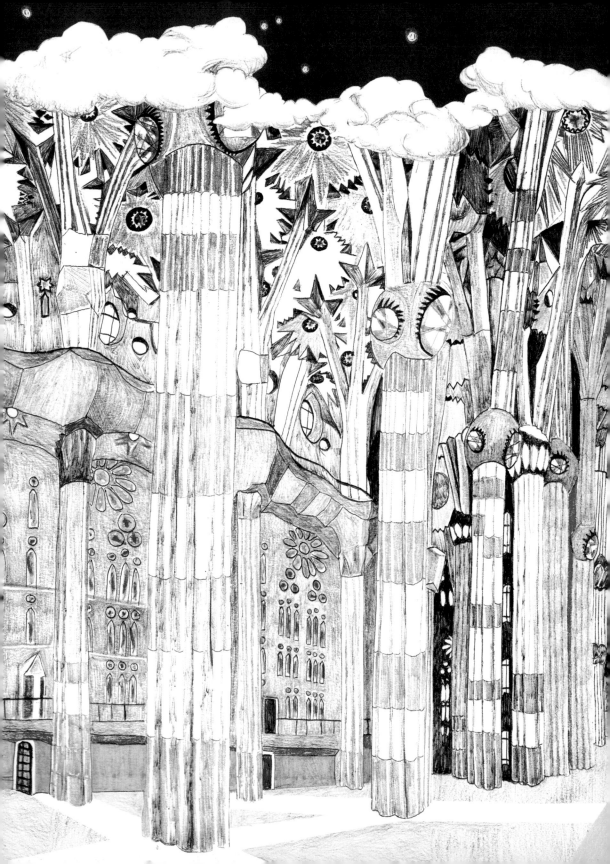

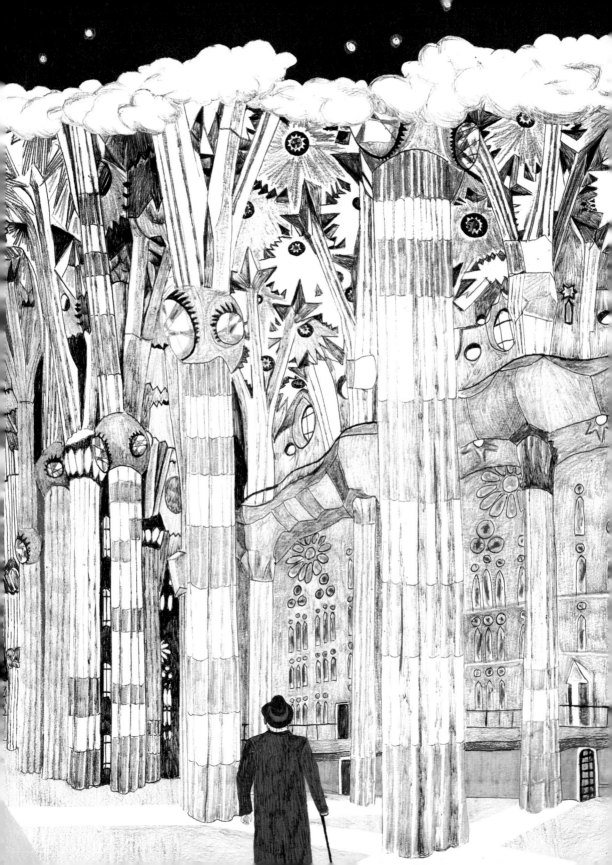

Antoni Gaudí
Josep Maria Subirachs, 1993
Private Collection

Sainthood

In 2014 it was reported in a Barcelona newspaper that over the previous 20 years the Associacio pro beatificacio d'Antoni Gaudí had been campaigning to have the great architect canonized as the patron saint of architects (admittedly, a place already held by several saints). The Associacio's application to the Vatican argued that he should be canonized because of his ability to work (architectural) miracles with the laws of nature while also embodying modern Catalan identity in his work.

In early 2015 it was announced that Chile, a country Gaudí never visited, was planning to build a Gaudí chapel. Gaudí had apparently received a letter in 1922 from a church friar in Rancagua requesting the design for a small town chapel. However, Gaudí chose not to design new plans for 'something original' that 'only you know how to do', as the friar had requested. Instead, he sent the friar plans he had designed in 1915 for a chapel within the Sagrada Família. Now, more than 100 years after he initially designed the chapel, it will be built.

Gaudí's popularity soars today, with millions visiting the yet-to-be-completed Sagrada Família every year, not to mention his other masterpieces scattered across Barcelona and beyond.

Author Acknowledgements

Thank you to my colleagues at The Bartlett and the AA for their input and feedback throughout the process of writing this book, particularly Ryan Dillon and Manuel Jimenez Garcia.

A special thanks to my editor Donald Dinwiddie to whom this book is highly indebted as well as to Liz Faber who patiently worked with me at the beginning of the writing process. And my utmost gratitude to Christina Christoforou without whose brilliant imagination and gorgeous illustrations this book would not have been possible.

Also thanks to the designer Alex Coco, to Rosie Fairhead, Julian León and Angelo Koo whose copy-edting, fact checking and proofreading were beyond price, to Peter Kent who tracked down all the photographs and Kim Wakefield who oversaw production and made sure the book was beautifully printed.

And finally, to my partner, Arran, your encouragement was, as always, invaluable.

Illustrator Acknowledgements

I would like to thank the editor of this book Donald Dinwiddie for his sharp eye; Brandon Gardner for watching series after series alone; and finally Luna the spoiled dog for making me take some breaks from drawing in order to serve her in some way.

Mollie Claypool

Mollie Claypool is a historian and theorist of architecture based in London. She is a Lecturer in Architecture at The Bartlett School of Architecture, UCL and also teaches at the AA School of Architecture.

Christina Christoforou

Christina Christoforou is a London-based illustrator and artist. She has produced work for the *New York Times*, Penguin Publishing and the National Theatre of Greece, and has worked as a lecturer in communication design. Her publications include *Whose Hair?* (2010), *This is Bacon* (2013) and *This is Leonardo da Vinci* (2016).

Picture credits

All illustrations by Christina Christoforou